The Art of Hand Lettering

CALLIGRAPHY TECHNIQUES AND EXERCISES

WHITE STAR PUBLISHERS

Editorial coordination

Giorgio Ferrero

Graphic design

Maria Cucchi

WS White Star Publishers® is a registered trademark
property of White Star s.r.l.

© 2018 White Star s.r.l.
Piazzale Luigi Cadorna, 6 - 20123 Milan, Italy
www.whitestar.it

Translation and Editing: TperTradurre s.r.l.

ISBN 978-88-544-1313-9
2 3 4 5 6 27 26 25 24 23

Printed in China

The Art of
Hand Lettering

CALLIGRAPHY TECHNIQUES
AND EXERCISES

Laura Toffaletti

Contents

Introduction

The history of writing and its numerous forms spans over more than six thousand years. This long process of development and elaboration is closely intertwined with the history of humankind and the need to communicate — which at a certain point could no longer be entrusted entirely to memory and oral tradition — with writing being portrayed and modified through the creation of an organized collection of increasingly sophisticated and powerful signs, symbols, lines and characters.

Initially writing was a practice; something so powerful that it was considered a supernatural invention, attributed to the ingenuity of Theuth, the Egyptian god of mathematics, geometry and wisdom, who — according to the myth — made it possible to preserve the essential characteristics of the world through the written word.

When Theuth presented his invention to the king of Egypt, expecting to be praised and credited for his creation, the king, after giving it due importance, pointed out that the mere mechanical recording of facts was not enough. It was also necessary to understand them and have access to the mechanisms of memory, not just to a recollection; that memory was an active function that seeks to fully grasp what must be remembered, while a recollection is just the memorization of something without understanding it.

The study of the evolution of alphabets has evidenced that the desire to leave a trace of oneself is an intrinsic part of human nature. Writing gave birth to the history of populations, and even if highly advanced civilizations originally used it for practical purposes, mainly for record keeping — for example, counting livestock and registering marriage contracts or harvests — this centuries-long journey has offered us the possibility to preserve and unequivocally transmit our thoughts, feelings and emotions.

Despite the great formal differences between more ancient characters — from Sumerian cuneiform script to Egyptian hieroglyphics and the Phoenician alphabet — right through to the modern fonts offered by present-day technology, the origin of everything that has been written over the past six thousand years derives from this fundamental impulse.

As Bruno Munari points out, the letters of an alphabet are actually composed of very few lines — vertical, horizontal, slanted — yet as well as assuming an understandable meaning, their countless combinations also lead to an unequivocal connotation.

The shape of the script is just as important as its function: identifying and understanding the particular structure of a character, as well as the historical, cultural and artistic stimuli behind its creation, is an extremely interesting way to learn about the design and aesthetic appearance of a character.

This manual is therefore an introduction and a guide to the fascinating world of calligraphy: an ancient discipline that transports us back in time and which is currently enjoying new vitality in many countries, despite — or perhaps because of — the unstoppable rise of computers, smartphones and media technologies that we use to communicate, and which are responsible for the written word becoming increasingly scarce and impersonal.

It is a discipline or, if one wishes, an art that requires rhythm, harmony and time; elements that increase the fascination that emerges from the use of different instruments which require passion, dexterity and an incredible amount of patience.

Today, thanks to the commitment and work of passionate and talented teachers, it is experiencing a come-back and arousing new interest, leading us to study the expressive potential of the written word, beyond simple communication. We all learnt how to write in order to communicate when we were children, yet we mustn't forget that the formal aspect of writing is no less important than the practical. Writing a certain word in a certain way, using a particular character, sometimes reveals much more about what we are thinking than the actual meaning of the word itself.

Calligraphy offers us the possibility to express our most profound feelings in a beautiful way; it is a passion carried out in a world of undefined boundaries, within which our sensitivity becomes fine-tuned, as does our ability to arrange the strokes on a blank white page in such a way that they become balanced as a whole.

Scribbling words while talking on the telephone; writing letters on a sheet of paper with the sole purpose of being decorative; or choosing to use a particular character in everyday writing: these are all habits that demonstrate excellent requisites for those who are passionate about pens and the alphabet and want to write beautifully. This manual will perhaps inspire you to do something new and unexpected — yet something that you will soon become familiar with — helping your writing to become not only descriptive, but also evocative.

Writing with words that are arranged rhythmically — free of their primary function — alternating between black and white, space and void, sound and silence, creating a kind of interior music that is visible on paper.

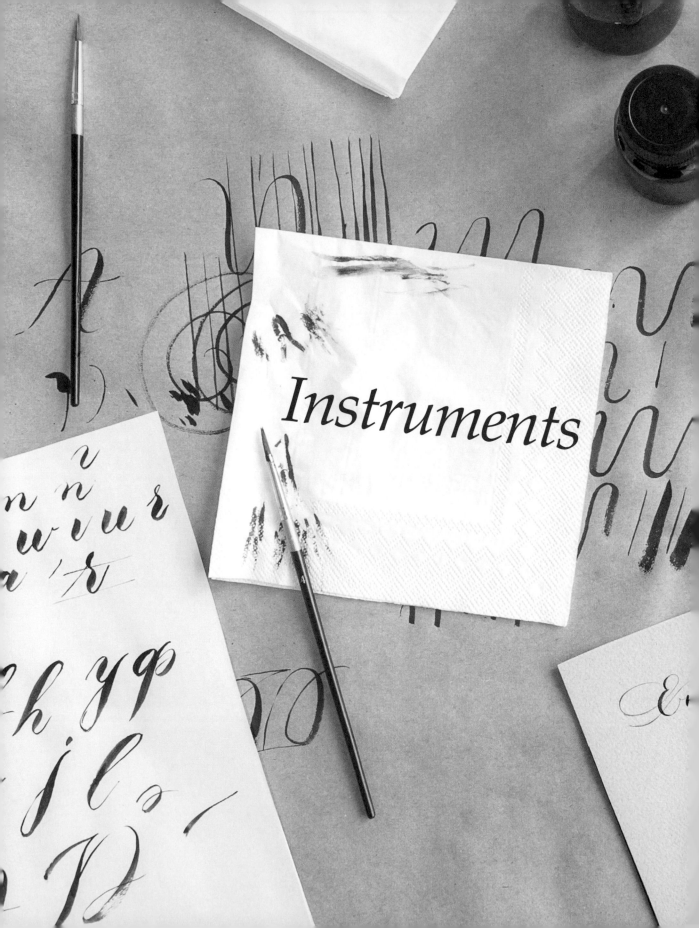

Instruments

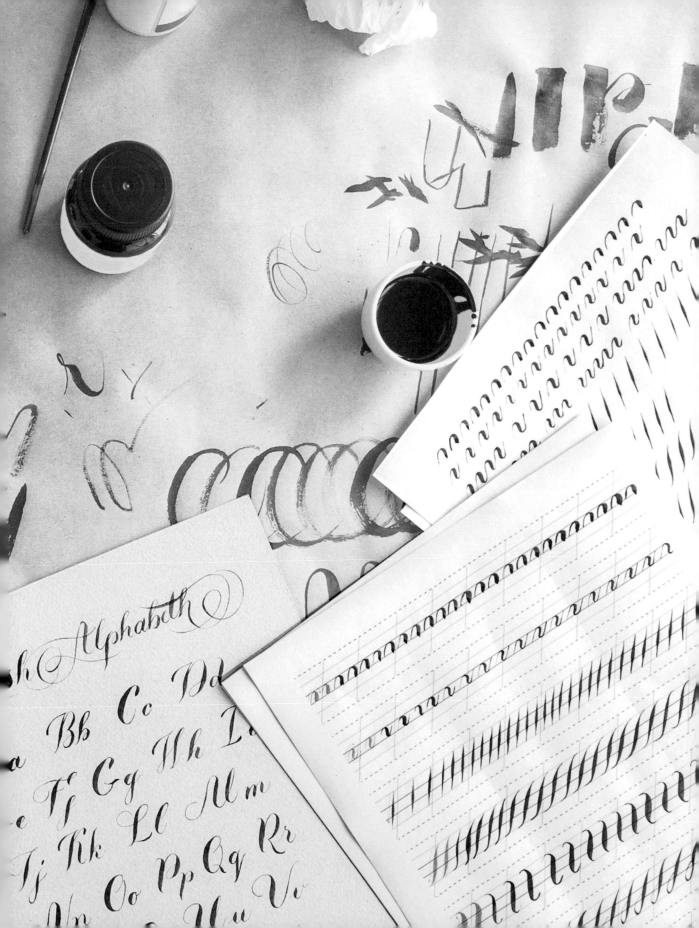

Алфавит

All the instruments used in calligraphy today derive from the reed pen and goose feather quill used in antiquity. The reed pen was made out of a piece of reed, by cutting it into a shaft-like shape; a goose feather quill was used to produce the illuminated manuscripts containing the Cistercian rules, which were decorated with gold. It was used for writing sacred texts and documents up to the end of the 19th century, when it was replaced by metal nibs produced in large numbers and available in many different models.

Today there is an incredible choice of materials and instruments and for those starting out in calligraphy it can often be overwhelming.

We will therefore provide a list of materials for creating a basic kit, which can be added to once you become more confident.

To achieve good results from the outset, it is best not to scrimp on materials, although in general they tend to have fairly affordable prices.

Use the best nibs, quality ink, good paper, high quality paints and brushes. Remember to clean the instruments thoroughly after use and to store them carefully so that they don't get damaged

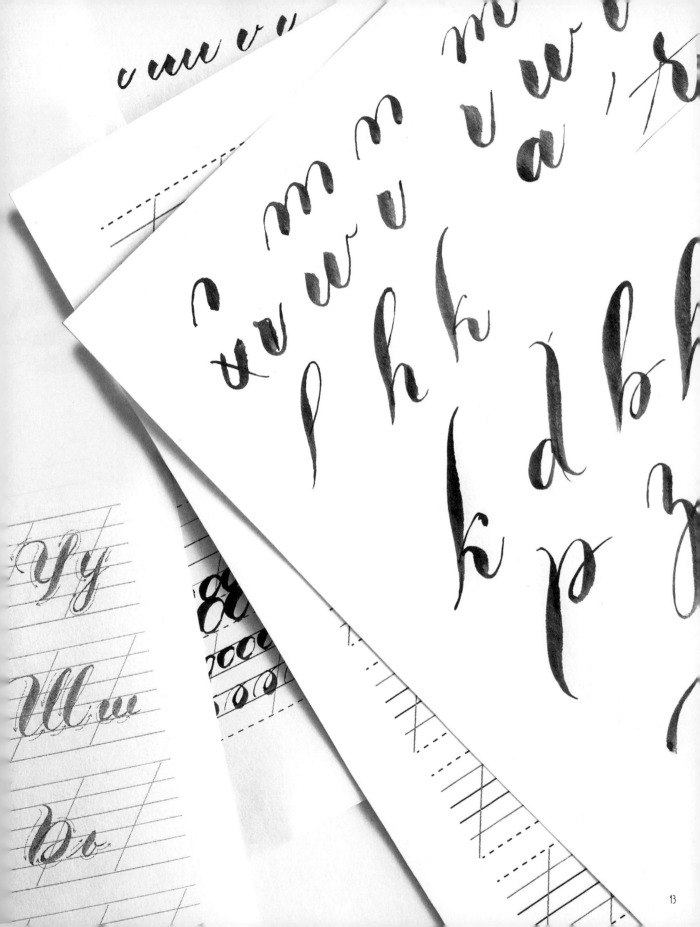

What You Need

Metal nibs

Calligraphy pens

Calligraphy markers

Nib holders

Black ink in a bottle or ink stick

16 lb (60 g) sketch paper

HB Pencil

Soft rubber

8-inch (20-cm) ruler

2 x triangles: 45° and 30/60°

Stanley knife

Absorbent paper towels or tissues

Scotch tape

Water

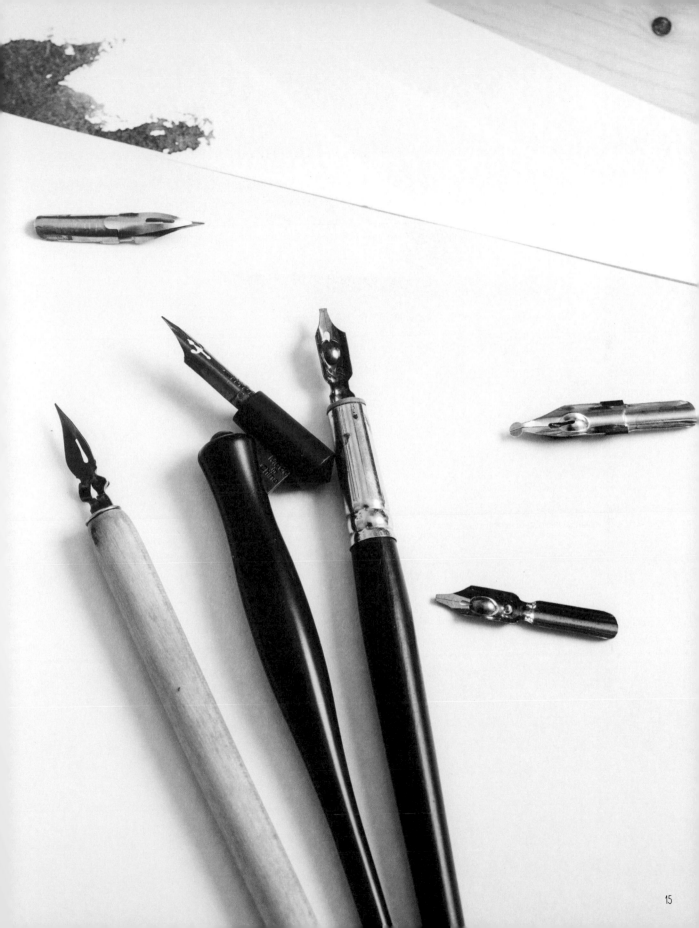

NIBS

There are several different types of nibs for calligraphy: chisel point, pointed, elbow, with a reservoir, round point.

CHISEL POINT NIBS

Metal chisel point nibs are the most suitable for beginners because they produce a sharp line.

Brause, Gillott, Soennecher and William Mitchell are among the leading brands; the alphabets in this manual were produced with the latter.

The William Mitchell Round Hand nibs are produced in a series of 10 numbers, including half sizes, with 6 being the narrowest and O the widest.

They come with a reservoir that ensures a regular and constant flow of ink: this is a single metal plate with prongs that attaches underneath the nib, approximately 3 mm from the tip.

The prongs shouldn't be closed too tightly, otherwise the tines of the nib will open and prevent you from producing a decent stroke.

Use a brush to place a few drops of ink into the space between the nib and the reservoir.

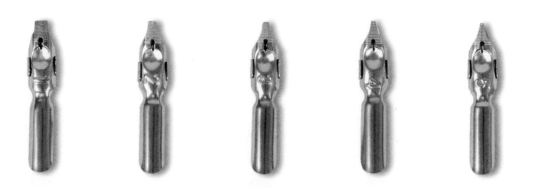

Speedball nibs also come with a reservoir, although it is attached above the nib and the ink flows from the top.

How to prepare a chisel point nib

Before starting to write, the thin coat of lacquer protecting the nib must be removed: hold the nib above a lighter flame for about ten seconds, then soak it in cold water and gently wipe the lacquer off with a cotton cloth.

It is important to remember that when using a chisel point nib, the thickness of the characters depends on the angle you hold the nib to the paper.

FLEXIBLE POINTED NIBS

Nowadays, pointed nibs are used mainly for English Cursive. They are flexible and versatile, available in the elbow version or to insert in an oblique nib holder; this is to help the writer achieve an otherwise difficult angle. They are not used with a reservoir and the thickness of the lines depends on the pressure applied to the tip of the nib, thereby releasing more or less ink.

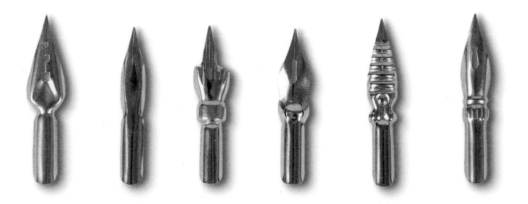

FOUNTAIN PENS

It is possible to find different types of fountain pens in stores, with various sizes of chisel point nibs.

The most common brands are Lamy, Sheaffer and the Rotring Art Pen. They are extremely practical because the ink is in a cartridge and available in lots of different colors.

Another type of fountain pen is the Pilot Parallel Pen: the nib consists of two parallel plates, allowing the writer to produce very sharp thin or thick lines.

AUTOMATIC PEN

Automatic pens have a diamond-shaped nib attached to a wooden pen handle, which holds a good quantity of ink or paint. They are designed for producing larger lettering, although they are not easy to find in stationery stores.

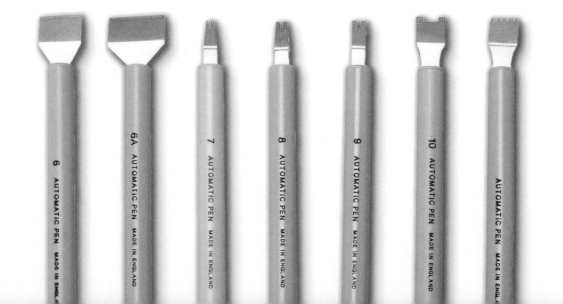

MARKERS

Calligraphy markers come with either a chisel point or a brush tip. The first are available with different-sized tips and in assorted colors. They are very useful in the preparatory stage of a project, as you can do the layout and establish the spaces very quickly.

Brush tips are perfect for expressive forms of writing; they use ink cartridges and come in many vibrant colors.

The best brands are Tombow, Pentel and Faber Castell.

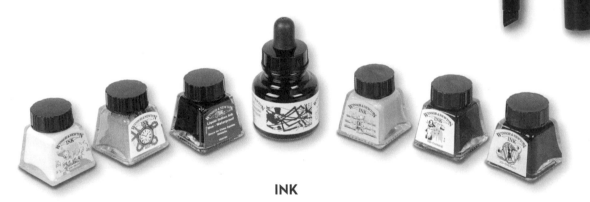

INK

Ink for calligraphy exercises is traditionally black and therefore easy to find in bottles in stationery stores: brands include Pelikan, Parker and Lamy, to name but a few.

For those of you who want to prepare your own ink, the best option is to use ink sticks, which you can find in most well-stocked Art Supply stores. The stick is made from carbon and resin and must be rubbed into a special container, adding distilled water little by little until the ink is the desired thickness and the right shade of black. It tends to dry very quickly, so it's best to just make the amount you need for what you are doing; it can't be stored and must be prepared from scratch each time.

Bottled inks can be found in a wide range of colors, by brands like Pelikan, Parker, Waterman and J. Herbin.

PAINTS

Other types of pigments used in calligraphy are gouache and watercolors, which produce different effects and results.

Gouache is opaque and produces sharper and more defined strokes, although there is a risk that it will crack while drying. To avoid this problem, just add a few drops of gum arabic. Watercolor produces very evocative translucent effects and the superposition of different colors. This can also be achieved with liquid watercolors (Ecoline), which must be loaded very carefully into the pen. They are in fact very thin and there is a risk of too much coming out and ruining your work.

We recommend Winsor & Newton watercolors, either pans or tubes, and Talens gouache.

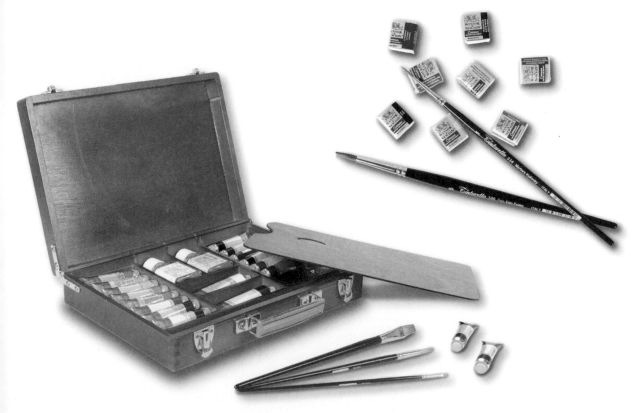

PAPER

The type of paper you use is important for the successful outcome of your work. Initially it's a good idea to use economic paper because you will use a lot of it, although it must have low absorbency so that the stroke doesn't feather or bleed, leaving jagged edges. Fabriano or Favini 16 lb (60 g) paper is good for practicing: the surface isn't too porous or too smooth, which slows down the ink's drying process. As you gain experience, your choice of paper will become very personal and depend on the result you want to achieve. In general, hand-made cotton paper is the best: it has a compact and uniform grain that is perfect for high-quality calligraphy work: the best types of paper are Amalfi, Rosaspina and Magnani, but there are various weights of watercolor paper that are just as good. You can experiment with different kinds and evaluate the characteristics of each one.

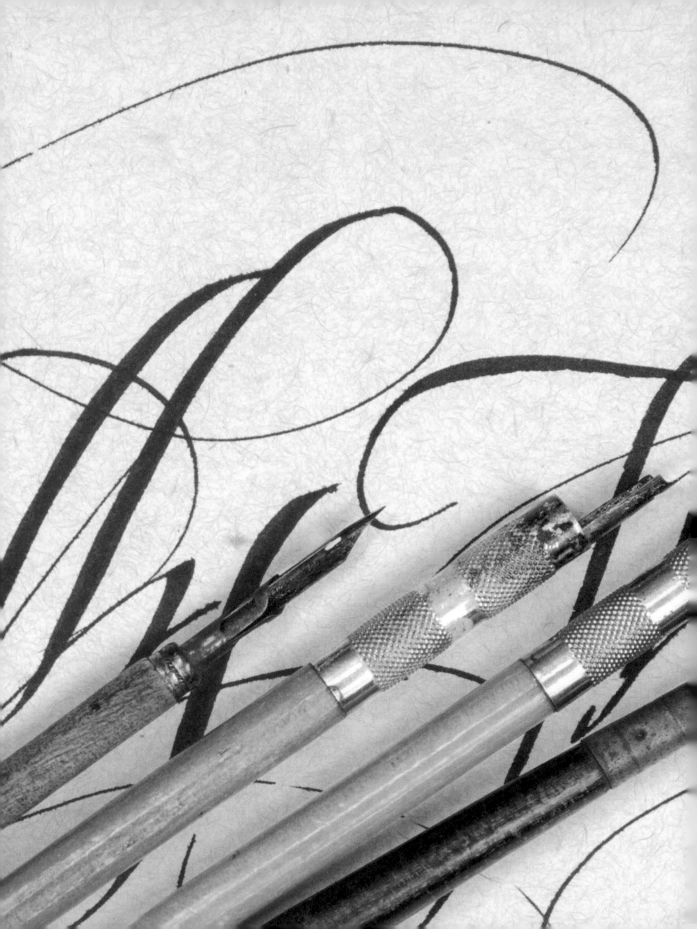

The pen is the tongue of the soul

Miguel de Cervantes

Terminology

Alphabet - The word comes from the names of the first two letters in the Greek alphabet: alpha and beta. An alphabet is a series of letters arranged in an ordered sequence.

Arch - The curved top or bottom of a letter.

Ascending letters - The letters with a stem that goes above the x-height: b, d, e, f, h, k, l, t.

Basic stem - A stroke with the same thickness throughout, i.e. a full pressure stroke.

Calligraphy - The art of forming beautiful characters with harmonious proportions: the word comes from two Greek words joined together: *kalòs* (beauty) and *graphein* (write).

Character - A symbol that is given a meaning; in this case, the shape of the letters in an alphabet.

Counter - The enclosed round or eye-shaped space in a letter.

Descending letters - The letters with a tail that goes below the baseline: g, j, p, q, y.

Ductus - The number and sequence of strokes that make up a letter.

Eurythmy - The uniform and constant appearance of each part of a piece of calligraphy.

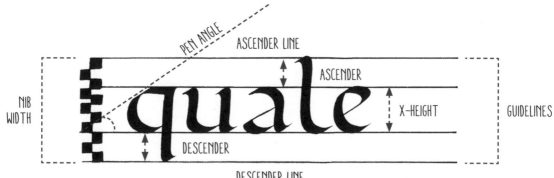

24

Full pressure stroke - The thickest part of a stem or curve.

Gradient - The slant of the letter, which may lean more or less to the right.

Guidelines or alignment lines - The lines that determine the height of lowercase and uppercase letters; they are established by the nib width.

Hairline or thin stroke - The thinnest part of a pen stroke; it is used to start, join or end letters.

Interlinear space - The vertical space between two lines of writing. It is the maximum stroke width of a chisel point nib.

Letters - Each of the characters in an alphabet which represents a sound.

Margin - The upper, lower or lateral space within which a page of writing is composed. Well-chosen margins create a balanced page.

Oblique or slanting character - One that slants varying degrees to the right.

Overturn stroke - The part of the thin stroke that gradually transitions to a full pressure stroke.

Parallelism - The consistent slant of the strokes of an alphabet.

Pen angle - The angle that the nib must be positioned on the paper to produce the strokes of the letters correctly; each calligraphy alphabet has its own pen angle.

Pen Nib Width - Serves to determine the height of the letters; each calligraphy alphabet has its own pen nib width.

Radicals or basic forms - The letters, or parts of a letter, which when combined form all the letters of the alphabet.

Space - The horizontal distance between letters and words.

Straight or vertical character - One that is perpendicular to the guidelines.

Stroke - A line made with a single movement of the pen.

Underturn stroke - The part of the thin stroke that gradually transitions from a full pressure stroke to a thin stroke.

X-height letters - The letters that sit between the baseline and the waistline: a, c, e, i, m, n, o, r, s, u, v, w, x, z.

Nib Width

A beautiful piece of calligraphy is composed of a set of constant characteristics that create harmony and which are pleasing to read; to achieve this, it is necessary to be aware of some basic elements.

The nib width is one of these: this is essential for determining the height of the letters and corresponds to the maximum thickness of the stroke produced by the nib on the paper.

Each calligraphy alphabet has its own established angle and even if it can be varied — as we shall see — when starting out it is best to respect it.

There are two ways to write the nib width on the page:
- draw square or rectangular strokes one above the other with the pen;
- draw a series of square or rectangular strokes across the page with the pen.

Once you've done this, measure the height of the space obtained, taking the ascending and descending letters into account, and use the same measurement to draw the guidelines within which you will start to write.

For example, the lowercase letters of Foundational hand have a nib width of 3/4.5/3, while that of the uppercase letters is 7.

This means that for the lowercase you need to consider a height of 3 nibs for the ascending letters, 4.5 for the regular letters and 3 for the descending letters; for the uppercase letters, the height of the guidelines will be 7 nibs.

Chancery hand has a nib width of 4/5/4 for the lowercase letters and 7.5 for the uppercase letters, and so on for all the other alphabets.

By maintaining the same nib width, you can produce heavier, darker letters with a wider nib; with a constant nib width, you can produce lighter letters with a finer nib.

In the same way, it is possible to produce variations with the same sized nib by reducing or increasing the nib width. In the first case, the letters will be heavier; in the second, they will be lighter.

We can also note that the variation in the weight of a letter affects its shape, and even if they are the same height, darker letters appear chunkier than the lighter ones.

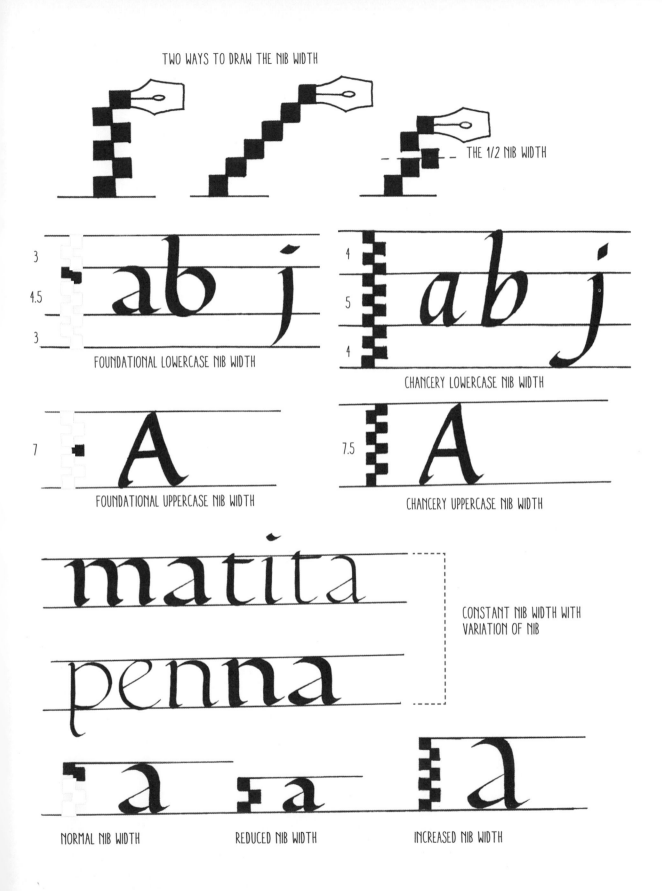

TWO WAYS TO DRAW THE NIB WIDTH

THE 1/2 NIB WIDTH

3
4.5
3
FOUNDATIONAL LOWERCASE NIB WIDTH

4
5
4
CHANCERY LOWERCASE NIB WIDTH

7
FOUNDATIONAL UPPERCASE NIB WIDTH

7.5
CHANCERY UPPERCASE NIB WIDTH

matita

penna

CONSTANT NIB WIDTH WITH VARIATION OF NIB

NORMAL NIB WIDTH REDUCED NIB WIDTH INCREASED NIB WIDTH

DRAWING THE GUIDELINES

To draw guidelines quickly, mark the height of the characters you have chosen on the edge of a sheet of paper, along with the height of the interlinear space.

Place the reference model next the edge of the piece of paper you are going to write on, then copy the measurements of the guidelines several times.

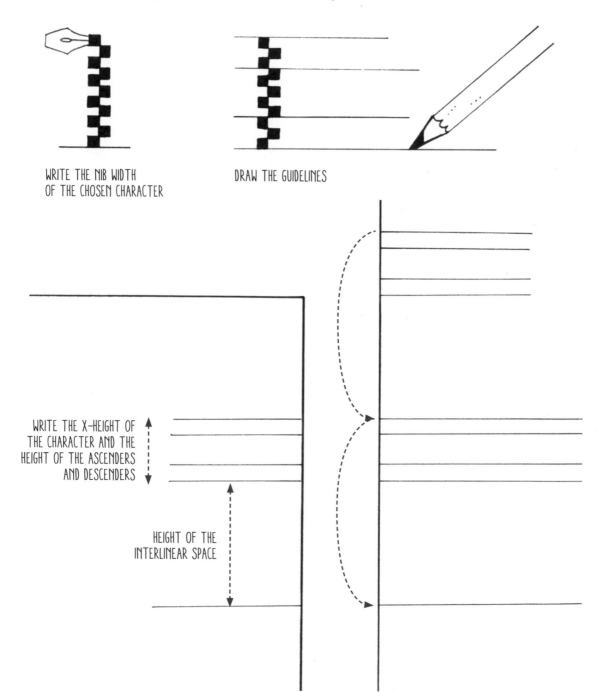

WRITE THE NIB WIDTH
OF THE CHOSEN CHARACTER

DRAW THE GUIDELINES

WRITE THE X-HEIGHT OF
THE CHARACTER AND THE
HEIGHT OF THE ASCENDERS
AND DESCENDERS

HEIGHT OF THE
INTERLINEAR SPACE

First Exercises

ANGLE

A wide pen is an unusual instrument that requires careful attention to the angle of the nib on the paper and, above all, to continuously maintaining it.

This is one of the most important elements of calligraphy, and you will find it difficult to achieve satisfactory results if you ignore it. Keeping the nib at the same angle throughout is fundamental.

In fact, producing the letters of an alphabet with the same width and shape depends on the correct angle, and despite being initially difficult, you will find that it makes writing easier.

Once you have established which alphabet you are going to write, the nib angle must always remain the same, subject to certain exceptions that are shown later on. If the nib is held at the wrong angle, it can result in letters that are too thin or thick, uneven stems and generally messy, confused handwriting. Although the nib angle may initially seem like an unnecessary difficulty, as you proceed with your calligraphy exercises you will notice that the wrong angle can be time consuming and frustrating; not to mention all the wasted paper.

NIB ANGLE

30° ANGLE 45° ANGLE 60° ANGLE

RADICALS

The appearance and construction of the letters in different alphabets depends on the ratios and proportions of the height and width.

RADICALS are the letters or parts of a letter which when combined form the other letters of the alphabet.

In general, the radicals are lowercase a, m and o.

The example shows the radicals of the Foundational and Chancery hands. As you can see, the differences between writing with the nib at 30 degrees and 45 degrees is clear, as is as the appearance of a vertical or oblique character. Furthermore, while the basic shape of Foundational hand is a circle inside a square, which makes the character very solid and wide, that of the Chancery hand is an ellipse inside a slanting rectangle, and therefore the character is narrower and more dynamic.

Maintaining the angle of the nib is therefore very important if you want to avoid errors and write each alphabet with respect for its specific characteristics.

RADICALS

30° FOUNDATIONAL

45° CHANCERY

Writing with a chisel point pen is like learning how to write for the second time: the characteristics, so to speak, of the letters that we are familiar with change; the writing instrument itself requires practice and discipline, and at the beginning it is therefore best to think of the characters as signs or, better still, as individual strokes rather than letters.

It is important to sit in a comfortable position when writing, at a table that is well lit, preferably with natural light coming from the left (or from the right for those of you who are left-handed). Ideally, the table should have a shallowly sloping sur-

face, between 30 and 45 degrees; a sloping writing surface will help you avoid the perspective distortion effect that a flat table creates when you look at the strokes, albeit minimal.

Sit comfortably, with both feet on the ground and your back straight but not rigid. There is no particular way in which you should hold the pen: it must feel as comfortable as possible in your hand and, above all, not impede the flow of the pen on the paper. The most important thing is that the final result is correct.

Using a fine-tipped brush, load the reservoir with a few drops of ink; it's important that you always check that there is not too much or too little ink on a separate piece of paper. If there is too much, the reservoir will drip; if there is too little, the nib will only leave a faint stroke.

The best paper for practicing on should weigh between 16 lb (60 g) and 21 lb (80 g): Fabriano or Favini sketch books are perfect because they combine low absorbency, a good level of transparency — which can be useful — and a good price: at the beginning you'll be throwing away a lot of paper, so it's best to practice on paper that doesn't cost too much; you can even use white or brown parcel paper.

Before starting to write, protect the lower part of the sheet of paper, where your hand touches, with another sheet of paper. This is because the natural moisture in your hand can gradually make the paper more absorbent, resulting in the lower part of the text having less defined and thicker strokes than the upper part. Sprinkling the sheet of paper with a layer of gum sandarac, which contains resin acids, will help you to produce clean, sharp strokes. You can find it in Art Supply stores: put a small amount of the powder in a cloth bag; close it and then gently pat the surface of paper.

If the nib is difficult to write with or produces uneven strokes, you might have forgotten to remove the protective lacquer, or you may not have positioned the reservoir properly.

It may simply be that you are applying too little or too much pressure to the pen, or that you are holding it at the wrong angle. These are all mistakes that will disappear with practice.

Each stroke must be made with the whole nib touching the paper, otherwise the edges will be uneven and not very sharp. Every so often, clean the nib with a clean, damp cotton cloth.

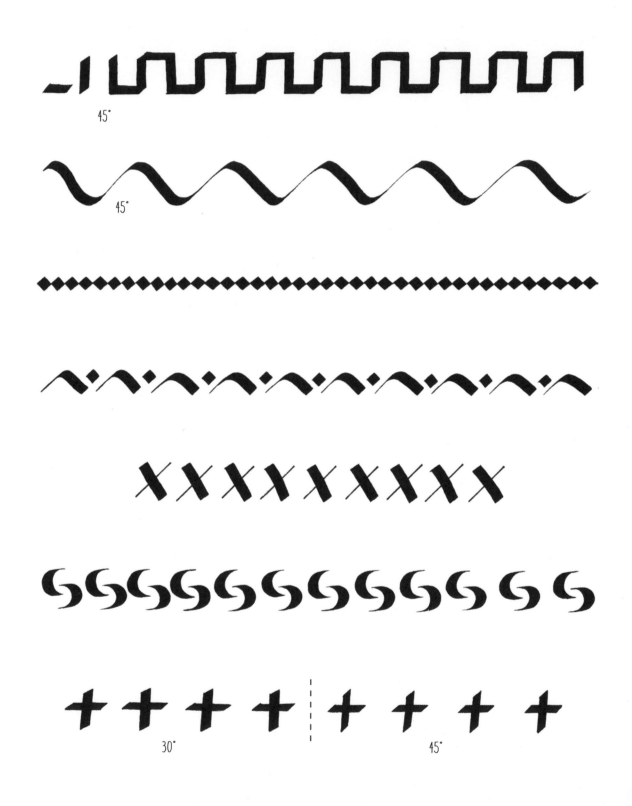

45°

45°

30° 45°

Start to familiarize yourself with the pen by drawing lines and seeing how the thickness of the strokes depends on the angle of the nib: get into the habit of working slowly, without haste, right from the start, and don't settle for anything less than your best. Calligraphy is a slow, precise art, which enables you to master each line and to repeat it in exactly the same way every time. Draw a few key patterns, waves or ornamental patterns, always focusing on the rhythm of your writing, that is, ensuring that the white spaces and black lines are balanced on the sheet of paper.

A good result is when you are able to create a constant rhythm in the space, with the strokes neither not too close together nor too far apart, which creates an irregularity that is ugly and confused.

After doing a few freestyle exercises to understand how the thickness and thinness of the line left by the nib can vary considerably, start to practice keeping your hand at the same angle all the time.

Draw a few guidelines, approximately 0.4 in (1 cm) apart. Using a triangle and a pencil, draw a series of lines at a 30-degree angle along the first guideline, about every 0.8 or 1.2 in (2-3 cm); do the same on the other guidelines you have drawn, although this time at a 45-degree angle. Holding the pen at the same angle, draw a series of zigzags, creating a frame in which solids and voids and thick and thin lines regularly recur and alternate. Note the differences between the 30 and 45-degree strokes.

Repeat the same exercise, but this time with a wave: the attack point and final tail of the strokes must have exactly the same angle.

Create frames that contain other elements, such as squares at the top or bottom, curved or wavy lines; the important thing is that you maintain the pen angle and that the pattern is regular. When you feel confident that you have mastered the strokes, you can start writing your first letters.

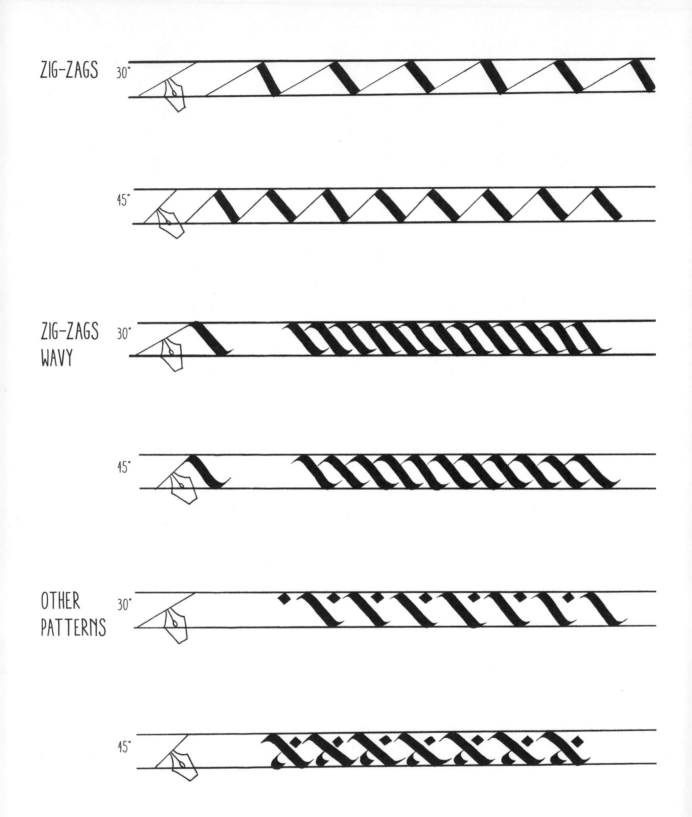

ZIG-ZAGS 30°

45°

ZIG-ZAGS
WAVY 30°

45°

OTHER
PATTERNS 30°

45°

THE SPACE BETWEEN LETTERS AND WORDS

The words we write on a piece of paper should be arranged as if they were a kind of fabric, where points that are too thick or thin should be considered an annoying defect that stands out to the trained eye (which you will soon have), as well as compromising the quality of the writing.

In calligraphy, there are a few pointers on the spaces between the letters; they are not rules as such, as there are too many character combinations, but rather guidelines on how to produce a harmonious end result. It's about understanding the relationship between the different shapes of the characters; how they affect the white of the paper, both inside and outside the letter.

Studying old examples and the work of contemporary master penmen is always a good way to acquire the sensibility needed to understand when the spacing between the letters and words is correct.

THE SPACE BETWEEN LETTERS

ii ibli io

VERTICAL LETTERS

om bo ov

ROUND LETTERS

vn ve vr

DIAGONAL LETTERS

Generally, in calligraphy:

- vertical letters are those which have the largest space between them in a word (double i, double l, etc.);
- round letters are those which have the smallest space between them, and at times they can even touch each other (double o, b and o, etc.);
- diagonal letters (double v, v and r) may also touch each other, and are usually closer to the following letter;
- capital letters are usually more spaced out than lowercase letters.

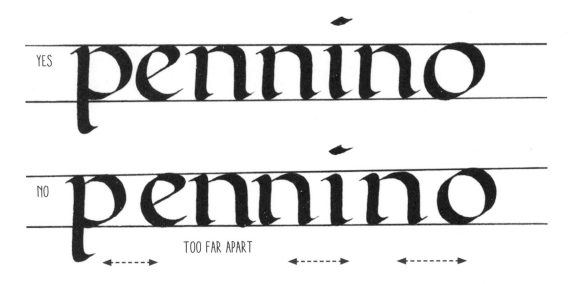

Writing the word MINIMUM is an excellent exercise for mastering strokes and spaces; make sure that the white between the arches and letters is balanced, and that you respect the parallelism of the strokes.

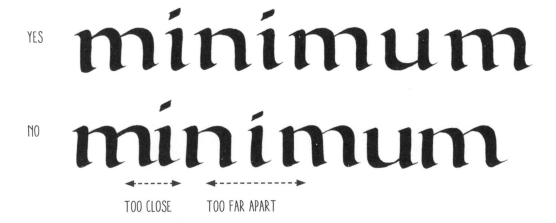

minimumminim

umminimummin

inimumminimum

←------------→
TOO CLOSE

minimum

minimum

minimum

minimum

For obvious reasons of legibility, the spaces between the words must be greater than those between each letter, although the space must not be so wide as to leave too much white: generally, the space between the words should be able to contain a lowercase letter "n".

INTERLINEAR SPACE

The interlinear space, i.e. the vertical space between two rows of writing, must be sufficient to ensure that the ascenders and descenders of an alphabet do not overlap.

There can be exceptions to the rule, depending on the effect that you want to achieve: if you want a block of compact text, the interlinear space can be reduced, just as it can be increased if you want more spaced-out text.

A good interlinear space is obtained by imagining that it is occupied by two over-lapping lowercase "o" of the alphabet you are using.

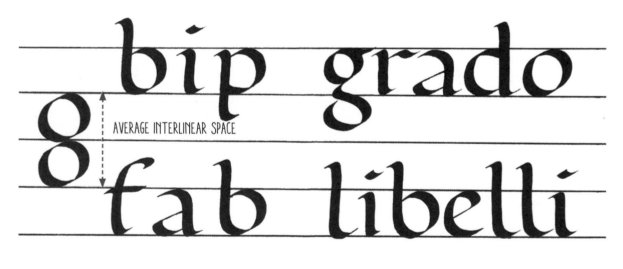

AVERAGE INTERLINEAR SPACE

INTERLINEAR SPACE

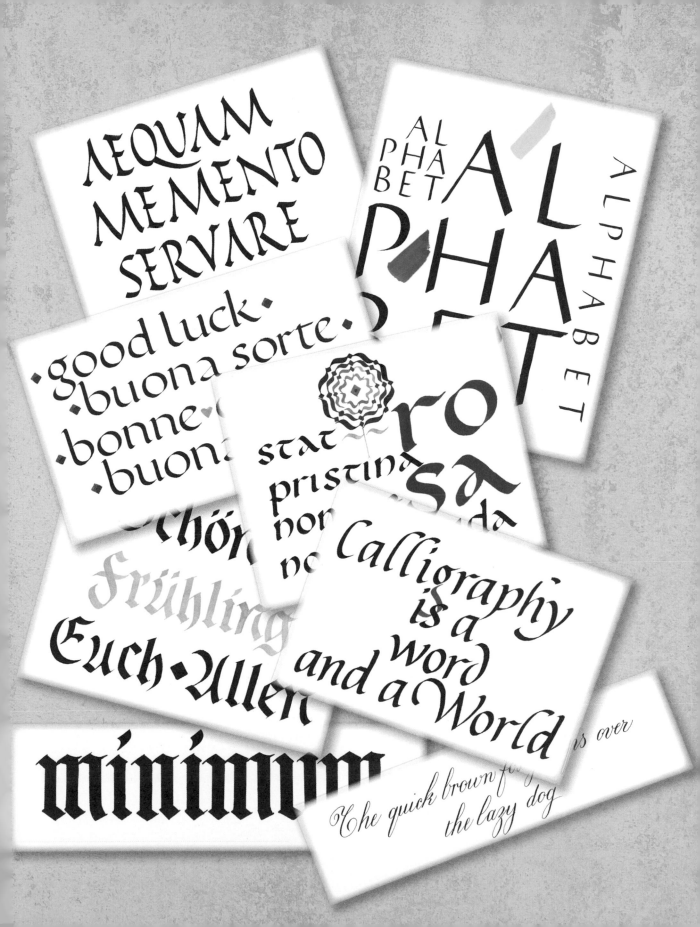

AEQUAM
MEMENTO
SERVARE

ALPHABET

AL
PHA
BET

AL
PHA
BET

A L P H A B E T

·good luck·
·buona sorte·
·bonne ·
·buona

stat
pristina
nom
no

ro
st

Calligraphy
is a
word
and a World

Frühling

Euch ·Allen

minimum

The quick brown fox the lazy dog is over

In this section, we present a selection of some of the most important alphabets in the history of writing. Some have their roots in ancient times: they are essential models that have defined, for both lowercase and uppercase letters, the most elegant and harmonious construction criteria. Others have stood the test the time, remaining almost unchanged for centuries, and are still being used today. And then there are those whose strokes have significantly changed, and their original appearance has almost entirely disappeared, together with our memory of them, yet they were still an important part of the journey of written communication.

As a more recent example, we have included an alphabet that was taught in Italian schools up until the beginning of the 1960s, and which has several counterparts in other countries. These pages will therefore offer you the opportunity to discover — or rediscover — the most important styles, using models, instructions and advice to approach an art that has forever marked the path of humanity.

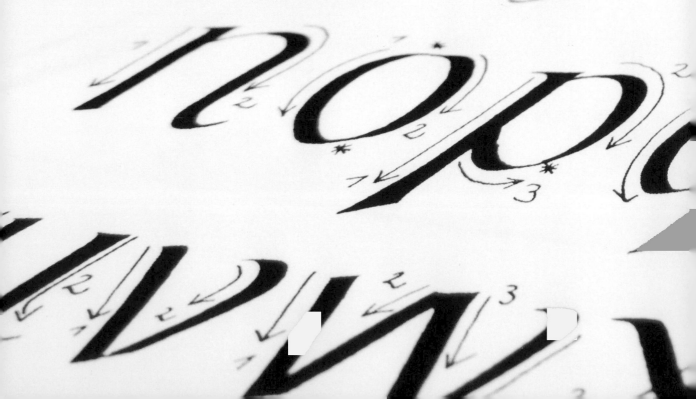

Alphabets

RUSTIC CAPITALS

Rustic Capitals — the term capitals defines alphabets made up entirely of majuscules — is a script characterized by its slender and laterally compressed letters and the stark contrast between the thin stems and thicker descending strokes.

It was most used between the 1st and 5th centuries A.D., as an alternative to the more solemn Roman Capitals for engravings on smaller monumental buildings, or painted lettering on banners, election proclamations and announcements on walls. The reed quill was used to produce beautiful manuscripts, as demonstrated by several works by Virgil, including the Eclogues, embellished with illuminated initials; a work by Publius Terentius Afer; and some works collecting minor pagan authors. The shapes are less rigid than those of Roman Capitals, with more curved strokes and descenders that go below the baselines. It was used less and less until about the 12th century, appearing mainly in the titles of books.

BASIC STROKES

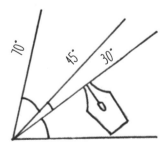

PEN ANGLE

BROKEN APART UPPERCASE LETTERS

2–30°
1–70°
3–70°
4–45°

CONSTRUCTION OF THE STEMS

7

NIB WIDTH 7

the most ancient form of the letter **A** doesn't have a crossbar

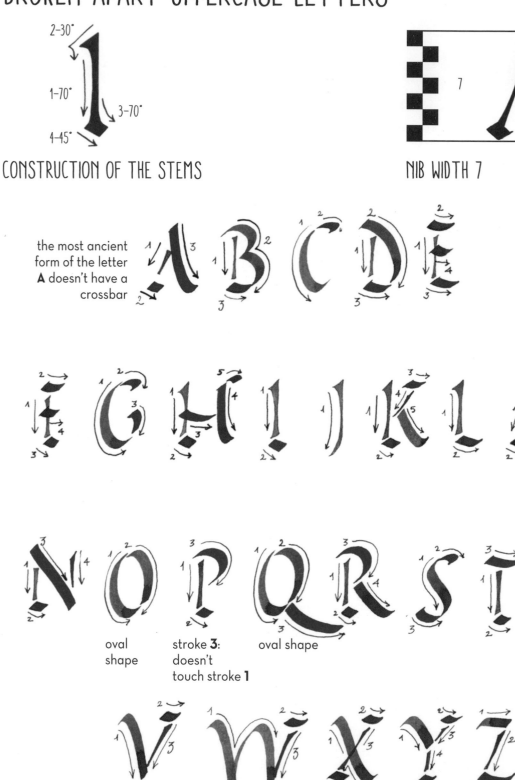

oval shape

stroke **3**: doesn't touch stroke **1**

oval shape

RUSTIC CAPITALS

A B C D E

F G H I J K L M

N O P Q R S T U

V W X Y Z

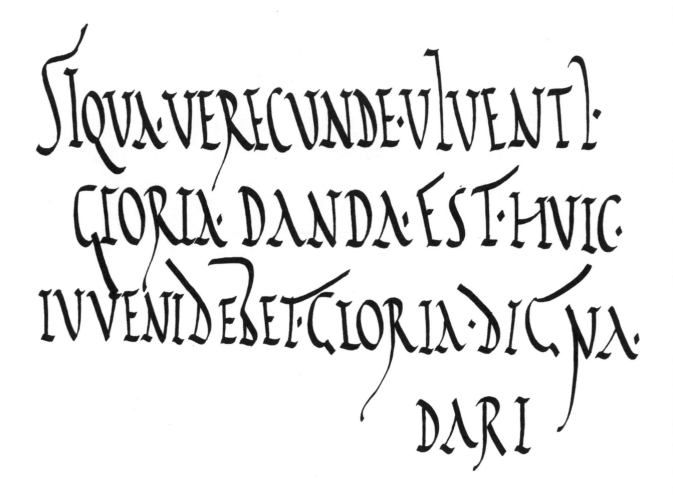

SIQVA·VERECVNDE·VIVENTI
GLORIA·DANDA·EST·HVIC·
IVVENIDEBET·GLORIA·DIGNA·
DARI

RUSTIC CAPITALS: GRAFFITI FOUND IN POMPEII

AEQUAM MEMENTO SERVARE MENTEM

"REMEMBER TO KEEP YOUR MIND EVEN" – HORACE

ROMAN CAPITALS

ROMAN CAPITALS ROMAN CAPITALS
ROMAN CAPITALS ROMAN CAPITALS
ROMAN CAPITALS ROMAN CAPITALS
ROMAN CAPITALS ROMAN CAPITALS
ROMAN CAPITALS ROMAN CAPITALS
ROMAN CAPITALS ROMAN CAPITALS
ROMAN CAPITALS ROMAN CAPITALS
ROMAN CAPITALS ROMAN CAPITALS
ROMAN CAPITALS ROMAN CAPITALS
ROMAN CAPITALS ROMAN CAPITALS
ROMAN CAPITALS ROMAN CAPITALS
ROMAN CAPITALS ROMAN CAPITALS
ROMAN CAPITALS ROMAN CAPITALS
ROMAN CAPITALS ROMAN CAPITALS
ROMAN CAPITALS ROMAN CAPITALS
ROMAN CAPITALS ROMAN CAPITALS

The formal perfection of the Roman capital reached its apex in the 2nd century A.D. The inscription at the base of the Trajan Column in Rome (113 A.D.) is a good example of the solemnity and formal harmony of the characters. During the Renaissance, the proportions of this alphabet were used as a model by both scholars and artists, from Albrecht Dürer to Luca Pacioli, who analyzed the structural principles to understand geometric perfection. The studies carried out by Father Edward Catich, an American priest, penman and teacher, proved fundamental, and in 1968 he explained the ductus of this script in his exhaustive work "The Origin of the Serif."

Engraved in stone using brush-drawn lines as a guide, the shape of Roman Capitals has remained unchanged for centuries; still today, it is impossible for designers of characters and script fonts to not use these letters as a reference point.

BASIC STROKES

PEN ANGLE

THE PROPORTIONS OF ROMAN CAPITALS

ROUND LETTERS AND NORMAL

NARROW LETTERS

WIDE LETTERS

The letters are divided into:

Round letters: **C, G, D**, and **Q** occupy the entire grid

Normal letters: **H, T, N, Z, A, X, Y, U, V** occupy **3/4** of the grid

Narrow letters: **E, K, F, B, I, P, L, R, J, S** occupy **1/2** of the grid

Wide letters: **M, W** are the width of the grid

ROUND LETTERS

NORMAL LETTERS

 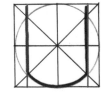

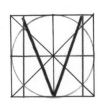 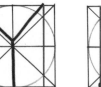 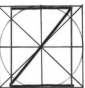

NARROW LETTERS

WIDE LETTERS

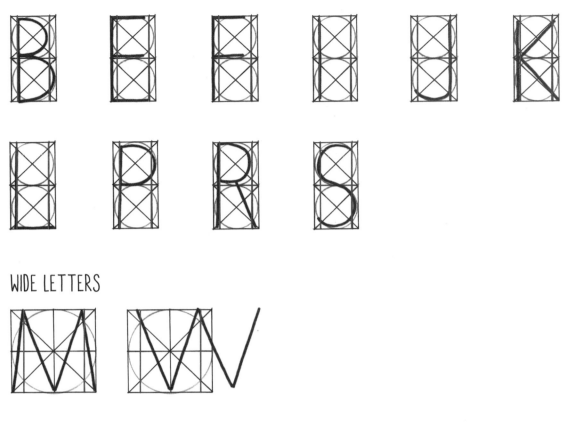

An excellent exercise to understand this structure, is to draw the grids of the 4 groups and then write the letters inside them with an HB pencil.

Do one group of letters at a time; study the shapes carefully and try to reproduce the strokes in one go, without having to go over them again with the pencil. When you feel you have mastered them, write the Capitals again, this time using the chisel point nib and a pen angle of 30 degrees.

CDGOQAHNTUVXYZ
BEFIJKLPRSMW

BROKEN APART UPPERCASE LETTERS

7 A

NIB WIDTH

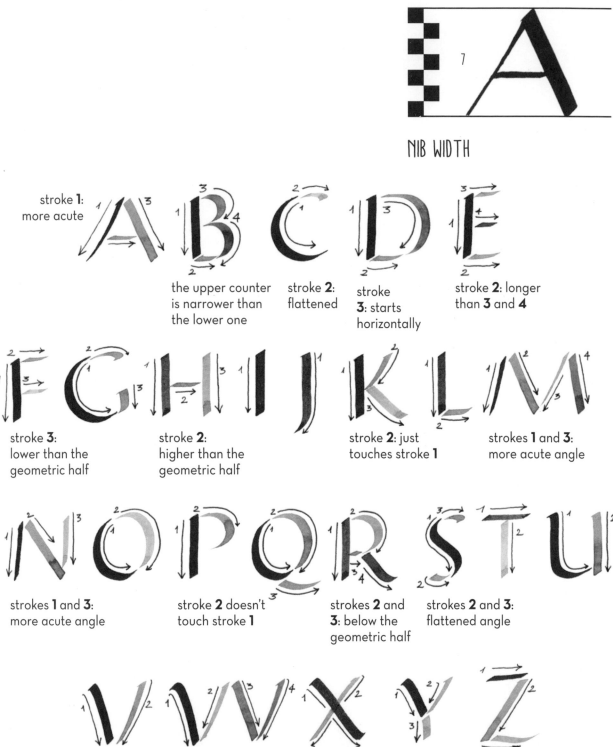

stroke **1**:
more acute

the upper counter
is narrower than
the lower one

stroke **2**:
flattened

stroke
3: starts
horizontally

stroke **2**: longer
than **3** and **4**

stroke **3**:
lower than the
geometric half

stroke **2**:
higher than the
geometric half

stroke **2**: just
touches stroke **1**

strokes **1** and **3**:
more acute angle

strokes **1** and **3**:
more acute angle

stroke **2** doesn't
touch stroke **1**

strokes **2** and
3: below the
geometric half

strokes **2** and **3**:
flattened angle

the oblique
strokes are at 45°

the **W** is **2 Vs**
side by side

the oblique
strokes are at 45°

stroke **2**
at 0°

52

ROMAN CAPITALS

A B C D E

F G H I J K L M

N O P Q R S T U

V W X Y Z

DUMLOQUI MURFUGER ITINVIDAA ETASCARPE DIEM

CARPE DIEM – HORACE

ALPHABET

A SIMPLE COMPOSITION OF UPPERCASE LETTERS TO EMBELLISH
WITH COLORED STROKES AND TEXT.

uncial uncial uncial uncial
uncial uncial uncial uncial
uncial uncial uncial uncial
uncial uncial uncial uncial
uncial uncial uncial uncial
uncial uncial uncial uncial
uncial uncial uncial uncial
uncial uncial uncial uncial
uncial uncial uncial uncial
uncial
uncial uncial uncial uncial
uncial uncial uncial uncial
uncial uncial uncial uncial
uncial uncial uncial uncial
uncial uncial uncial uncial
uncial uncial uncial uncial
uncial uncial uncial uncial
uncial uncial uncial uncial

With the fall of the Roman Empire, the form of writing underwent significant changes to fulfil the need for a more practical character than the complex Capital: the Uncial alphabet, once again a majuscule script, developed between 400 and 800 A.D., and the letters were more curved than those of previous ones. It was never used for inscriptions on monuments, mainly in books and early Christian texts, also thanks to it being easier and quicker to write. It became the script par excellence for illuminated manuscripts and was used by Latin and Byzantine scribes to compose magnificent texts on parchment, often illuminated with gold and silver leaf.

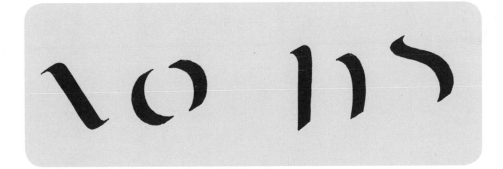

BASIC STROKES

PEN ANGLE

BROKEN APART UPPERCASE LETTERS

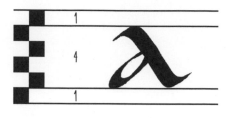

CONSTRUCTION OF THE STEMS

NIB WIDTH

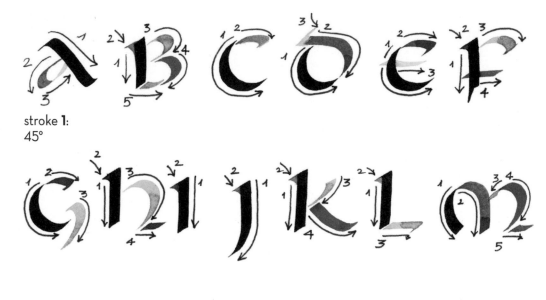

stroke **1**:
45°

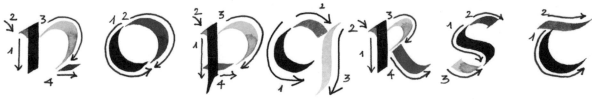

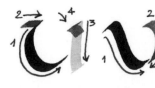

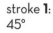

stroke **1**:
45°

stroke **1 and 2**:
45°

stroke **1 and 2**:
45°

stroke **2**:
0°

UNCIAL

A B C D E F

G H I J K L M

N O P Q R S T

U V W X Y Z

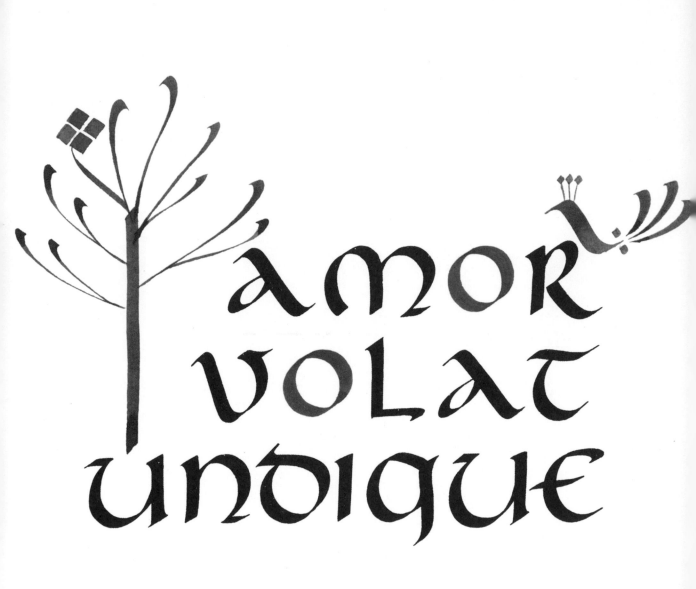

AMOR VOLAT UNDIQUE – CARMINA BURANA

LETTRESDE

DIMENSIONS aA

DEFORMES AA

DEMATIÈRES aA

ETDECOULEURS a

DIFFERÉNTES

TOUTESJETÉES

JOYEUSEMENTEN

L'AIR

"LETTERS OF DIFFERENT SIZES, SHAPES, MATERIALS AND COLORS,
TOSSED IN THE AIR WITH JOY" – BRUNO MUNARI

carolingian carolingian carolingian
carolingian carolingian carolingian
carolingian carolingian carolingian
carolingian carolingian carolingian
carolingian carolingian carolingian
carolingian carolingian carolingian
carolingian carolingian carolingian
carolingian carolingian carolingian

carolingian

carolingian carolingian carolingian
carolingian carolingian carolingian
carolingian carolingian carolingian
carolingian carolingian carolingian
carolingian carolingian carolingian
carolingian carolingian carolingian
carolingian carolingian carolingian
carolingian carolingian carolingian

The Carolingian Minuscule or Carolina script, takes its name from Charlemagne, who, during his reign in the 8th and 9th centuries, promoted a huge campaign for cultural reform. Deriving from the Uncial and Half Uncial scripts, it was used by the chancery and was elaborated and formalized by the Benedictine monks of Corbie Abbey in France: it is characterized by its clarity and club serifs, which are typical of this script. Carolina hand is slightly sloping, although it still has an extremely readable rounded appearance. Thanks to these characteristics, combined with the speed with which it could be written, it spread rapidly throughout Europe, thereby simplifying communication and imparting new impetus to classical culture.

Interesting fact: the Carolingian script introduced the question mark for the first time in the history of writing.

Modern lowercase letters derive from its forms.

BASIC STROKES

PEN ANGLE

WRITING SLANT

BROKEN APART LOWERCASE LETTERS

letter **b** letter **f**

CONSTRUCTION OF THE STEMS

NIB WIDTH

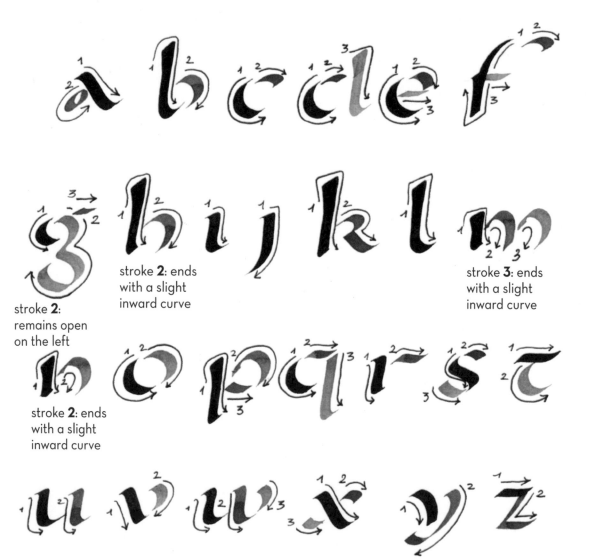

stroke **2**: remains open on the left

stroke **2**: ends with a slight inward curve

stroke **3**: ends with a slight inward curve

stroke **2**: ends with a slight inward curve

carolingian

a b c d e f

g h i j k l m

n o p q r s t

u v w x y z

stat ~ ro
pristina
nomine sa
nomina nuda
tenemus

DE CONPTEMPTU MUNDI – BERNARD OF CLUNY

ave · formosissima
gemma · pretiosa
ave · decus
virginum
virgo ⊙ gloriosa
ave · mundi
luminar
ave · mundi · rosa

AVE FORMOSISSIMA – CARMINA BURANA

Textura Textura Textura Textura Textura
Textura Textura Textura Textura Textura
Textura Textura Textura Textura Textura
Textura Textura Textura Textura Textura
Textura Textura Textura Textura Textura
Textura Textura Textura Textura Textura
Textura Textura Textura Textura Textura

Textura

Textura Textura Textura Textura Textura
Textura Textura Textura Textura Textura
Textura Textura Textura Textura Textura
Textura Textura Textura Textura Textura
Textura Textura Textura Textura Textura
Textura Textura Textura Textura Textura

This is one of the so-called Gothic scripts, originating between the 11th and 12th centuries, which clearly moved away from previous formal characters; it mainly spread across northern Europe. Gothic scripts are characterized by their jagged, compact and heavy form with reduced spacing, which on paper or parchment form a kind of thick weave; this is the reason why Gothic script was also called "Blackletter." There are different versions of Gothic script: these include Schwabacher, Fraktur and, naturally, Textura, the font used by Johannes Gutenberg to print his first Bible with movable metal type.

The line spacing is reduced considerably in the Textura hand, becoming approximately as high as the letter "x"; to make it easier to read — which was not that simple — the dot on the letter "i" was introduced. Another characteristic of this alphabet is the distance between the letters and words, approximately equal to the width of the stem.

BASIC STROKES

PEN ANGLE

VERTICAL STROKES 35°;
SLANTING STROKES 45°

BROKEN APART LOWERCASE LETTERS

YES NO

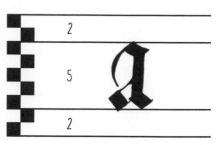

CONSTRUCTION OF THE LETTERS

the diagonal strokes have different angles

CONSTRUCTION OF THE STEMS

b, d, h, k: the upper serif is fine, with an angle of about 10 degrees
t and **f**: the horizontal stroke is completed with one corner of the nib

NIB WIDTH

2

5

2

stroke **4**: lift the right side of the nib

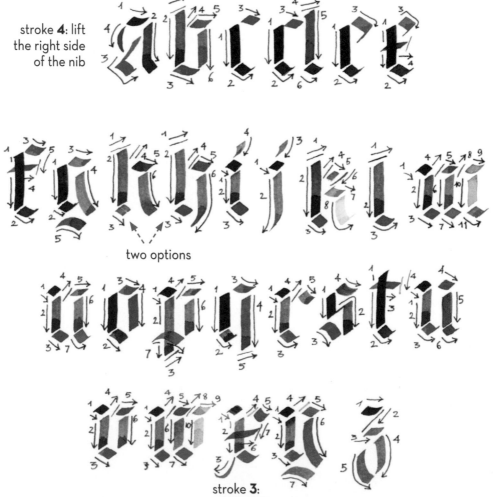

two options

stroke **3**: nib at 90°

Textura

a b c d e

f g h h i j k l m

n o p q r s t u

v w x y z

BROKEN APART UPPERCASE LETTERS

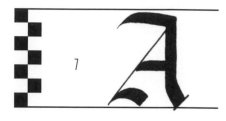

7

NIB WIDTH

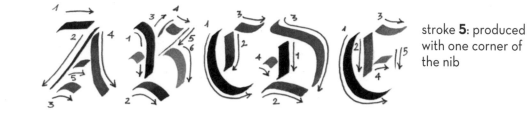

stroke **5**: produced with one corner of the nib

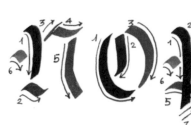

stroke **5**: produced with one corner of the nib

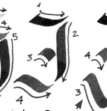

stokes **2** and **3** drop below the baseline

look at the letter **R**

stroke **1**: not vertical but sloping slightly to the right

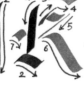

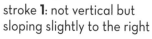

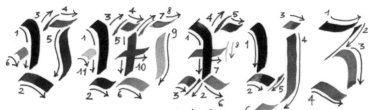

stroke **8**: produced with one corner of the nib

ABCDE

FGHIJKLM

NOPQRSTU

VWXYZ

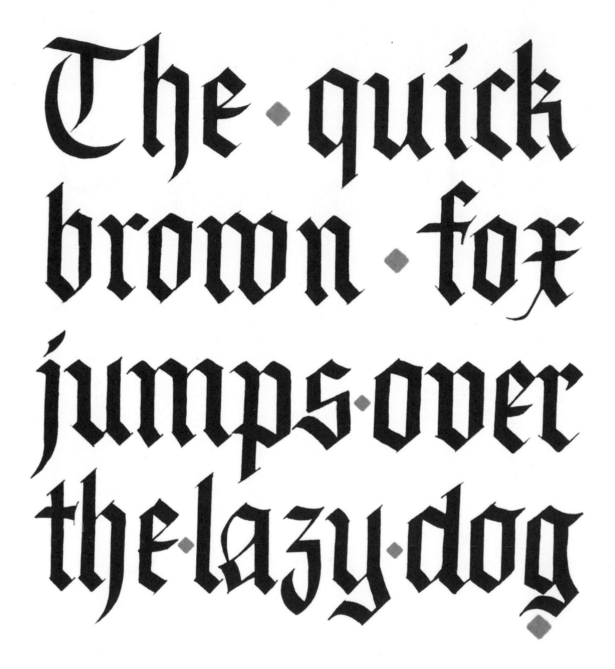

The · quick brown · fox jumps·over the·lazy·dog

A PHRASE THAT CONTAINS ALL THE LETTERS OF THE ALPHABET AT LEAST ONCE,
WITH VARIATIONS IN SPACING

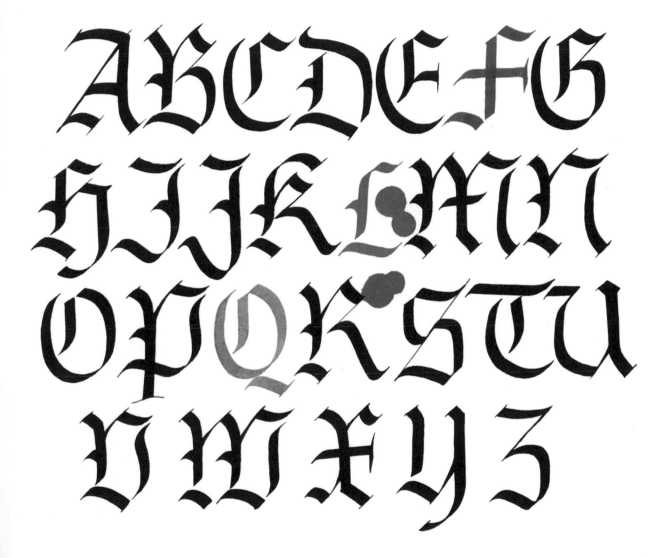

COMPOSITION OF UPPERCASE LETTERS

Fraktur Fraktur Fraktur Fraktur
Fraktur Fraktur Fraktur Fraktur
Fraktur Fraktur Fraktur Fraktur
Fraktur Fraktur Fraktur Fraktur
Fraktur Fraktur Fraktur Fraktur
Fraktur Fraktur Fraktur Fraktur
Fraktur Fraktur Fraktur Fraktur

Fraktur

Fraktur Fraktur Fraktur Fraktur
Fraktur Fraktur Fraktur Fraktur
Fraktur Fraktur Fraktur Fraktur
Fraktur Fraktur Fraktur Fraktur
Fraktur Fraktur Fraktur Fraktur
Fraktur Fraktur Fraktur Fraktur

Whereas Textura has an extremely rigid square shape, the lines of the Fraktur alphabet — which also belongs to the family of Gothic scripts — are slightly softer, interrupted and broken up — hence the name — at the same time maintaining the proportions of a compact letter.

The first examples of this script date back to around 1400, but it did not become widely used until it was elaborated by the Chancery of Maximilian I, in Bohemia. Its popularity continued right through to the Baroque period in the 17th century. Germany's most illustrious scribes contributed to perfecting the script and it was not long before it was being used as an elegant script at court.

The success of the Fraktur script continued in Germanic countries right up to the 20th century, and only stopped being used in the 1940s.

BASIC STROKES

PEN ANGLE

VERTICAL STROKES 35°;
SLANTING STROKES 45°

BROKEN APART LOWERCASE LETTERS

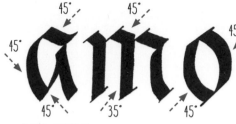

PEN ANGLE

vertical stroke 35 degrees;
slanted and curved strokes
45 degrees

for the **f** and **long s**, this
is produced by drawing a
vertical tail with the nib

NIB WIDTH

	2
	5
	2

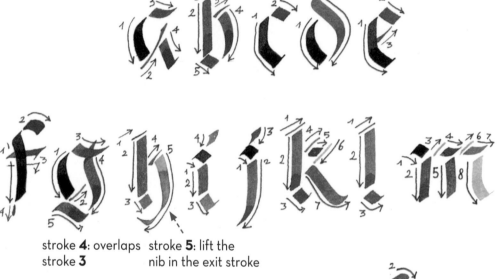

stroke **4**: overlaps
stroke **3**

stroke **5**: lift the
nib in the exit stroke

the most ancient form

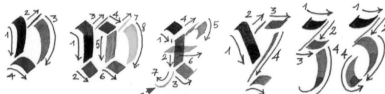

stroke **7**: lift the
nib in the exit stroke

fraktur

a b c d e

f g h i j k l m

n o p q r s f t u

v w x y z z

BROKEN APART UPPERCASE LETTERS

7

NIB WIDTH

look at the
letter **U**

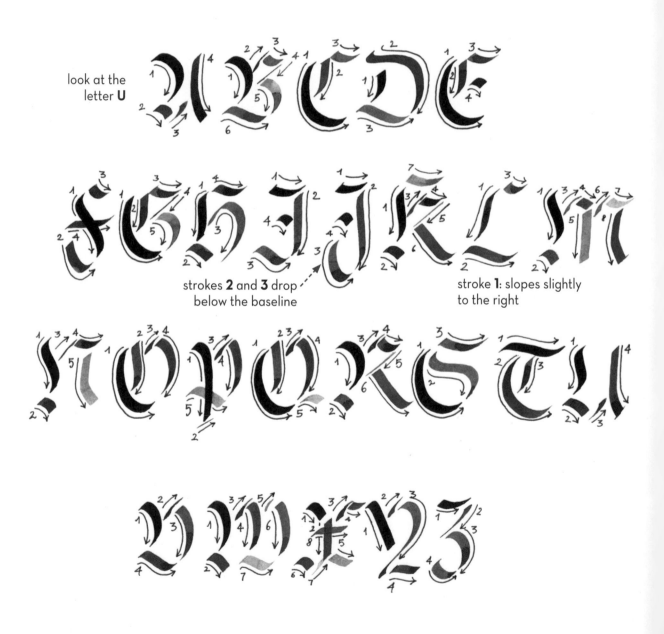

strokes **2** and **3** drop
below the baseline

stroke **1**: slopes slightly
to the right

ABCDE

FGHIJKLM

NOPQRSTU

VWXYZ

Tempus·est
iocundum
o·virgines
modo·congaudete
vos·iuvenes
oh oh·totus floreo

TEMPUS EST IOCUNDUM – CARMINA BURANA

Schönen Frühling Euch·Allen

A SPRING GREETING

Foundational Foundational Foundational
Foundational Foundational Foundational
Foundational Foundational Foundational
Foundational Foundational Foundational
Foundational Foundational Foundational
Foundational Foundational Foundational
Foundational Foundational Foundational
Foundational Foundational Foundational

Foundational

Foundational Foundational Foundational
Foundational Foundational Foundational
Foundational Foundational Foundational
Foundational Foundational Foundational
Foundational Foundational Foundational
Foundational Foundational Foundational
Foundational Foundational Foundational
Foundational Foundational Foundational

The Foundational hand was devised at the beginning of the 20th century, by English Master penman Edward Johnston, who elaborated the forms of the Carolingian script in the Harley Manuscript 2904 (Ramsey Psalter) — preserved in the British Library in London — with a view to using it for purely educational purposes. It is a straight font, with regular spaces, wide arches and a generally rounded appearance: in fact, the forms of Foundational hand are established by the letter "o"; round and uniform.

Originally created to be taught in schools to make writing easier, thanks to the few variations in the pen angle, it has always had a practical use.

The uppercase letters of this alphabet derive from an elaborated version of Roman Capitals.

BASIC STROKES

PEN ANGLE

BROKEN APART LOWERCASE LETTERS

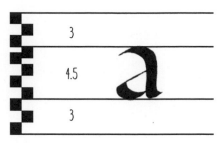

NIB WIDTH

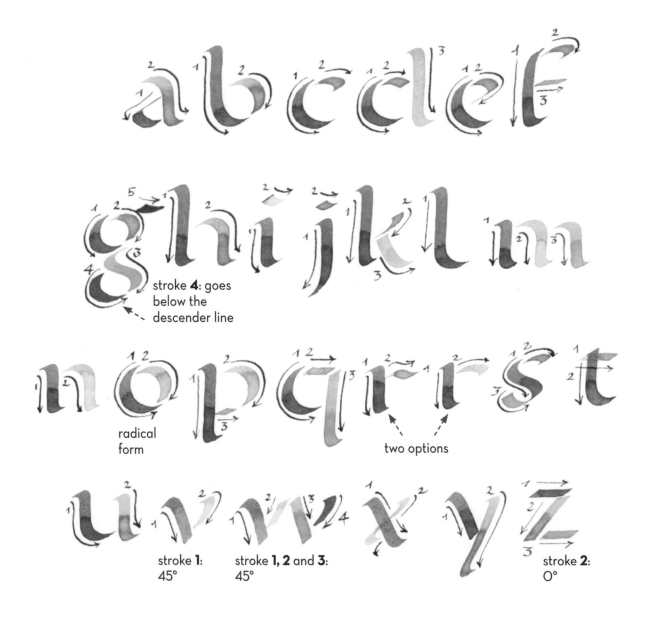

stroke **4**: goes
below the
descender line

radical
form

two options

stroke **1**:
45°

stroke **1, 2** and **3**:
45°

stroke **2**:
0°

86

Foundational

a b c d e f

g h i j k l m

n o p q r r s t

u v w x y z

BROKEN APART UPPERCASE LETTERS

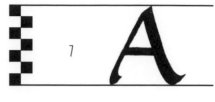

NIB WIDTH

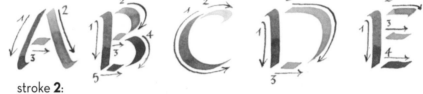

stroke **2**:
45°

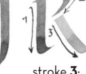
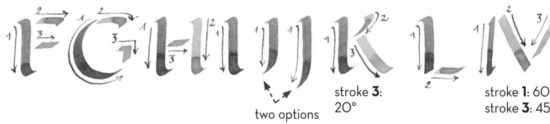

two options

stroke **3**:
20°

stroke **1**: 60°;
stroke **3**: 45°

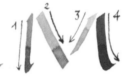
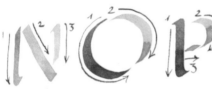

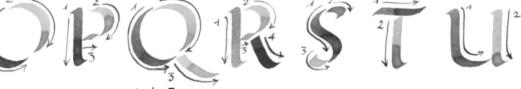

strokes **1** and **3**:
60°

stroke **3**:
20°

stroke **1**:
45°

stroke **2**:
0°

ABCDE

FGHIJJKLM

NOPQRSTU

VWXYZ

BROKEN APART NUMBERS AND COMPOSITE NUMBERS

1 2 3 4 5 6 7 8 9 0

1 2 3 4 5 6 7 8 9 0

The numbers ascend and descend from the baseline

◆ good luck ◆

◆ buona sorte ◆

◆ bonne ♥ chance ◆

◆ buona vita ◆

GOOD LUCK!

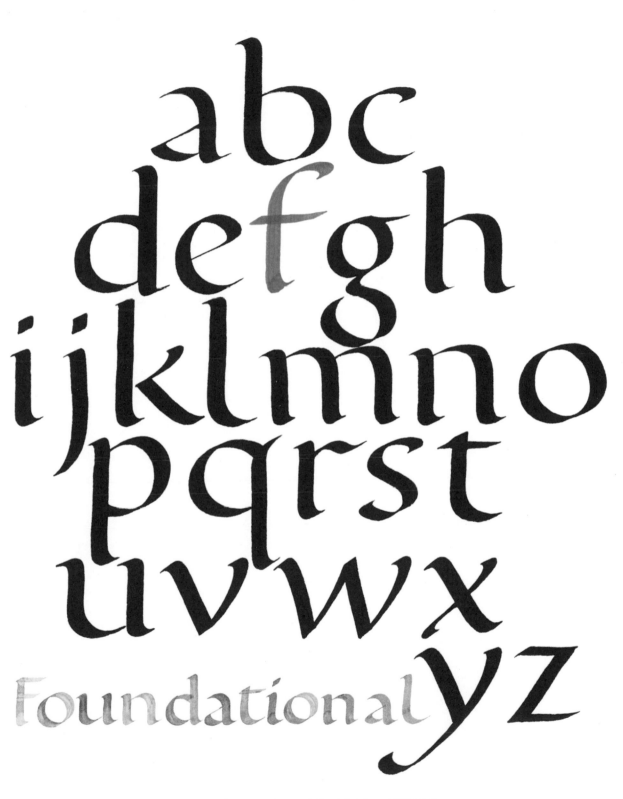

abc
defgh
ijklmno
pqrst
uvwx
Foundational yz

A COMPOSITION OF UPPERCASE LETTERS

Roundband Roundband Roundband
Roundband Roundband Roundband
Roundband Roundband Roundband
Roundband Roundband Roundband
Roundband Roundband Roundband
Roundband Roundband Roundband
Roundband Roundband Roundband

Roundband

Roundband Roundband Roundband
Roundband Roundband Roundband
Roundband Roundband Roundband
Roundband Roundband Roundband
Roundband Roundband Roundband
Roundband Roundband Roundband

The Roundhand font shown here is part of the series of 46 characters in the manual "Metodo Esemplare Calligrafico" published by Giuseppe Capretz, founder of the magazine "Calligrafia" and a calligraphy teacher in Padua in 1930s. The manual, adopted by the Italian Ministry of Public Education, was widely used in all the schools in the Kingdom of Italy, from elementary schools to high schools, and it is still possible to find copies in antique markets. The Roundhand script is based on practicality and simplicity, and is an elaboration of the French font of the same name that was popular in around 1850. Used for headers and to evidence parts of text, in schools at the time it was considered the most important vertical broad pen script after Cursive.

BASIC STROKES

PEN ANGLE

BROKEN APART LOWERCASE LETTERS

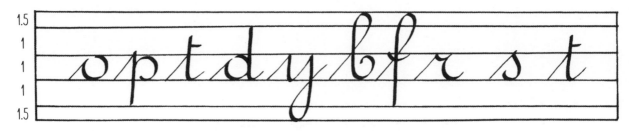

HEIGHT OF THE ASCENDING, DESCENDING AND UPPERCASE LETTERS

The height of the characters is not established by the nib width but by the proportional relationship between the lowercase and uppercase letters, which can be defined as: **1.5/1/1/1.5**; the height of the ascending letters is **1/1/1.5**, except for **d**, which is **1/1** and **t**, lower than the **d**.
The height of the x-height letters is **1**.
The height of the descending letters is **1/1/1.5**, except for **p** and **q**, which are **1/1**.

the stoke
remains open the stoke
 remains open

is different the stoke the stoke is different
from the **u** remains open remains open from the **n**

Roundhand

a b c d e f

g h i j k l m

n o p q r s t u

v w x y z

BROKEN APART UPPERCASE LETTERS

0.5	
1	
1	
1	
0.5	

Most of the uppercase letters are produced
with a single stroke.

HEIGHT OF THE CHARACTER

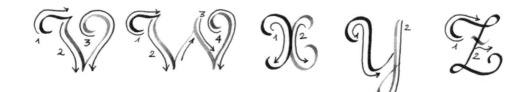

A B C D E

F G H I J K L M

N O P Q R S T U

V W X Y Z

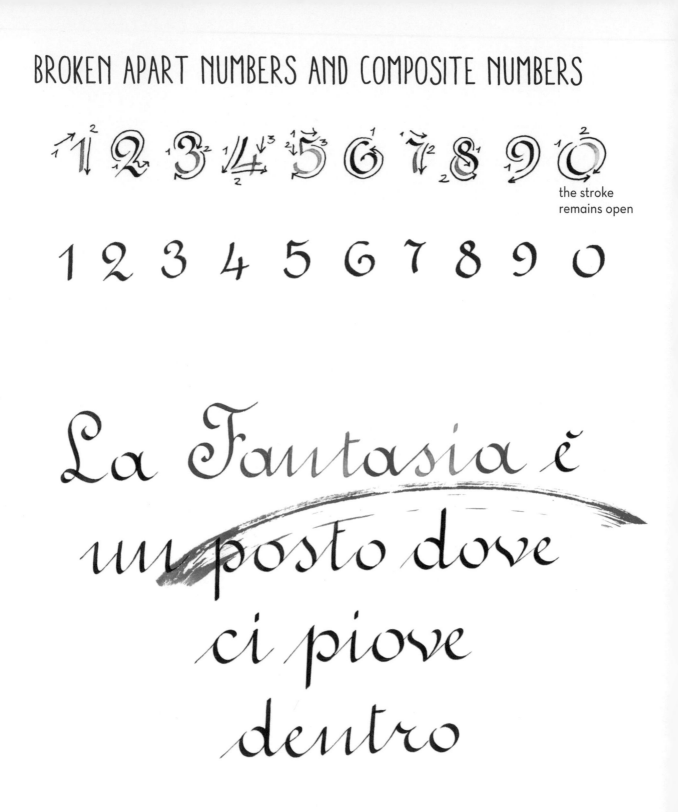

the stroke
remains open

"FANTASY IS A PLACE WHERE IT RAINS" – ITALO CALVINO

Arezzo, Berlin, Como, Dresden, Este, Firenze, Genève, Haiti, Ivrea, Kent, London, Milano, Napoli, Orvieto, Paris, Quito, Rimini, Siena, Torino, Udine, Venezia, Worms, Xeres, York, Zara.

A CALLIGRAPHY EXAMPLE WITH THE NAMES OF SOME CITIES IN ALPHABETIC ORDER

Chancery Chancery Chancery Chancery
Chancery Chancery Chancery Chancery
Chancery Chancery Chancery Chancery
Chancery Chancery Chancery Chancery
Chancery Chancery Chancery Chancery
Chancery Chancery Chancery Chancery
Chancery Chancery Chancery Chancery

Chancery

Chancery Chancery Chancery Chancery
Chancery Chancery Chancery Chancery
Chancery Chancery Chancery Chancery
Chancery Chancery Chancery Chancery
Chancery Chancery Chancery Chancery
Chancery Chancery Chancery Chancery

In 1522, Italian scribe Ludovico Degli Arrighi, known as Vicentino, wrote a treatise in a new type of italic script with elegant and functional strokes, which developed in parallel with humanist texts during the Renaissance. In "La Operina", the title of the short treatise, Vicentino formalized every aspect of this script — devised due to the need for an elegant, fluid font to draw up official documents — which was used in the Chancery of the Papal States; this is how the "littera cancellarescha" took its name. This font, also known as Italic, is sloping, narrow and dynamic. Based on an oval shape inside a rectangle, sloping slightly to the right, it is one of the most flexible scripts, maintaining an ultra-modern look and still used today in the most diverse areas of communication.

BASIC STROKES

PEN ANGLE

WRITING SLANT

BROKEN APART LOWERCASE LETTERS

a: radical letter; stroke **1** = in **d, g, q**; upside down in **b** and **p**. **m** and **n**: the arches are the same, as is that of the **h**.

NIB WIDTH

radical
letter

a b c d e f f

two options

g g h i j k l m

the counter
is smaller

two options

the curve
is wider

n o p q r r s t

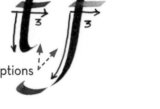

u v v w x y z

stroke **2**:
0°

Chancery

a b c d e f f

g g h i j k l m

n o p q r r s t

u v w x y z

BROKEN APART UPPERCASE LETTERS

7,5

NIB WIDTH

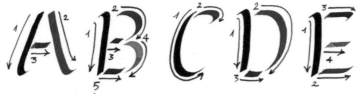

the upper counter
is smaller than the
lower one

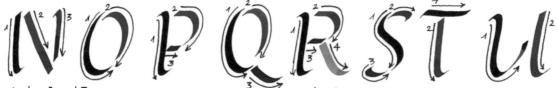

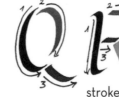

strokes **1** and **3**:
between 50°/60°

stroke **4**:
30°

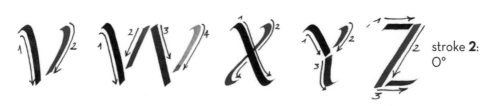

stroke **2**:
0°

A B C D E

F G H I J K L M

N O P Q R S T U

V W X Y Z

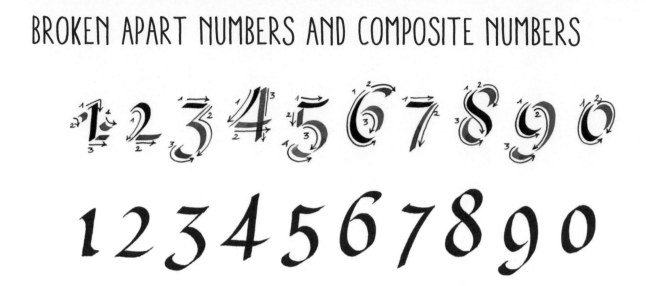

The numbers are bouncy

Calligraphy
is a
word
and a World

Nelle *aiuole*
ci sono
tutte le vocali,
una consonante
e tanti fiori.

"IN `AIUOLE´ (FLOWERBEDS), THERE ARE ALL THE VOWELS,
ONE CONSONANT AND LOTS OF FLOWERS." – FAUSTO MELOTTI

English cursive

One of the most representative alphabets written with a flexible nib is the English Cursive, a script that developed in England at the beginning of the 18th century and which spread rapidly throughout Europe. This font has two main characteristics: the stark contrast between the thin and thick stokes, and the decisive 55-degree right slant.

The elbow nib, which takes its name from the characteristic shape, was invented to make the letters easier to write — it helps the writer write faster and to achieve an otherwise difficult pen angle — although a normal flexible nib inserted into an oblique nib holder works just as well.

Initially it was a purely commercial font, but today it is known as an elegant script, used for formal texts and announcing important events.

Unlike the chisel point nib, the thickness of the strokes produced by a flexible nib are determined by the pressure that the hand exerts on the pen.

BASIC STROKES

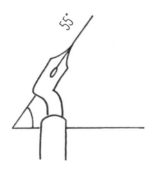

The **pressure on the nib** is very important: to produce the thick lines correctly, place the nib on the paper and press down to open the tip; pull the nib down, maintaining the same pressure throughout. To produce thin strokes, lighten the pressure.

PEN ANGLE

BROKEN APART LOWERCASE LETTERS

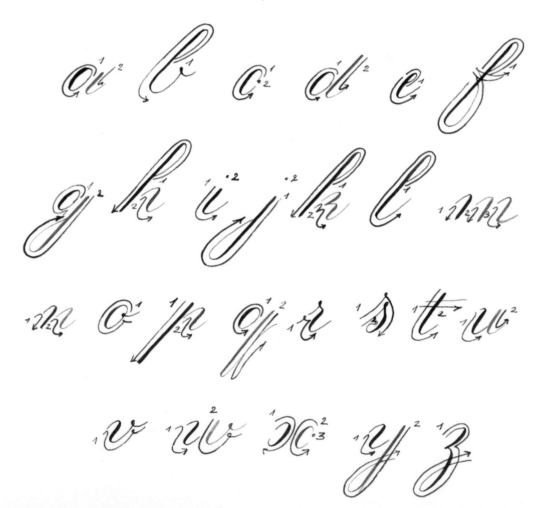

HEIGHT OF THE ASCENDERS AND DESCENDERS

In English Cursive, the height of the characters is not established by the nib width like in tall alphabets, but by the proportional relationship between the lowercase and uppercase letters, which can be defined as **3/2/3**: the height of the ascending letters is **3** units; the height of the x-height letters is **2** units; the height of the descending letters is **3** units.

Some letters, such as the **t, d, q** and **p**, are shorter, while the uppercase letters are the same height as the ascending letters. The letter **a** is radical. The **1** stroke is the same in **d, g, o, q**. The letters **b, e, f, i, j, o, r, s, v, z** are written with one stroke. The letter **m, n, h** and **p** have the same arch.

English cursive

a b c d e f

g h i j k l m

n o p q r s t u

v w x y z

BROKEN APART UPPERCASE LETTERS

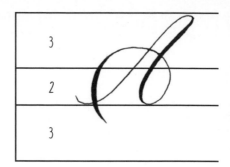

The uppercase letters in English Cursive are fairly large and it requires a little practice to not run out of ink by the middle of a stroke; parts of the letters are written with one movement.

HEIGHT OF THE CHARACTER

$\mathcal{A}\ \mathcal{B}\ \mathcal{C}\ \mathcal{D}\ \mathcal{E}\ \mathcal{F}\ \mathcal{G}$

$\mathcal{H}\ \mathcal{I}\ \mathcal{K}\ \mathcal{L}\ \mathcal{M}\ \mathcal{N}$

$\mathcal{O}\ \mathcal{P}\ \mathcal{Q}\ \mathcal{R}\ \mathcal{S}\ \mathcal{T}\ \mathcal{U}$

$\mathcal{V}\ \mathcal{W}\ \mathcal{X}\ \mathcal{Y}\ \mathcal{Z}$

BROKEN APART NUMBERS AND COMPOSITE NUMBERS

1 2 3 4 5 6 7 8 9 0

1 2 3 4 5 6 7 8 9 0

The quick brown fox jumps over the lazy dog

Pack my box with five dozen liquor jugs

TWO SENTENCES FOR PRACTICING ALL THE LETTERS OF THE ALPHABET.

Im Garten meiner Mutter steht
Ein weisser Birkenbaum,
Ein leiser Wind im Laube geht
So leis, man hört ihn kaum.

Hermann Hesse

"IN THE GARDEN OF MY MOTHER STANDS A WHITE BIRCH TREE. A QUIET WIND PASSES THROUGH ITS FOLIAGE, SO QUIETLY THAT ONE SCARCELY HEARS IT." – HERMANN HESSE

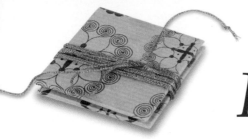

Projects

A FEW TIPS BEFORE STARTING

Preparing the layout and choosing the materials for a calligraphy project is a lot of fun. It is extremely rewarding when you achieve the desired result and is the best way to apply everything you have learnt.

Calligraphy can be used for a wide variety of projects: elegant greeting cards; invitations; traditional cards for Christmas, birthdays or baptisms; parchment scrolls for degree certificates; poetic manuscripts; small handwritten and hand-bound volumes; clothing; and much more.

Step by step, you will discover that calligraphy can enhance and embellish many different types of objects, as well as offer the possibility to create original and personal solutions.

This manual proposes a series of very simple yet extremely effective projects, to copy or redesign using your creativity.

WHAT YOU NEED

Once you have chosen the project you want to do, check that you have all the necessary materials before starting: rough paper, pencils and rubbers, a ruler and triangles, scissors and a cutter, a compass, glue and scotch tape, card and paper for the final product, the right-colored inks, metal nibs.

Calligraphy markers are also very useful in the preparatory stage for doing quick sketches.

Choose the font and practice writing with different-sized nibs and different-colored inks; this will help you make a few decisions:

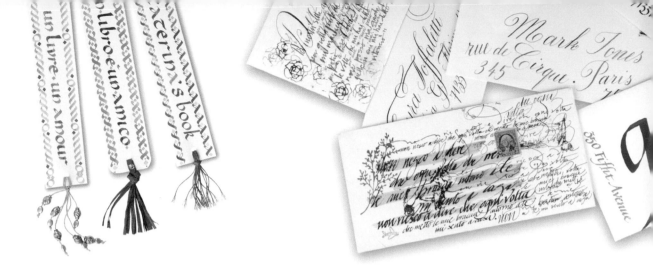

- the size of the text; the right layout for the text (horizontal, vertical, central, aligned to the right or left...);
- where to evidence one or more words using a different nib width;
- where to evidence one or more words using a different color;
- where to evidence a single letter in the text with a different nib width or color.

Once you've made these decisions, you can start writing the text on a piece of rough paper, measuring the phrases or words that you want to emphasize and writing the measurement down the side of the piece of paper in pencil.

Photocopy and cut out the sentences, then create one or more rough copies by gluing them on to another sheet of paper: this will give you more accurate references to help you understand any changes or adjustments you need to make to obtain the best result.

The choice of paper for the final product is also important and depends on the result you want; try out both smooth and textured paper to decide which one is best suited to your project.

Before continuing, check one last time that the text is well-balanced.

You're now ready to do the final copy. Draw faint guidelines with a soft pencil that is easy to erase and copy the measurements accurately; take the pen you have chosen to use and start writing.

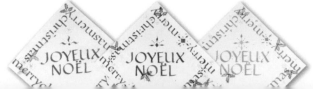

Spiral

Drawing a spiral is very simple if you have a compass; you can also draw it freehand, but we recommend that you rely on geometry the first few times.

1 Divide the middle of the page vertically and horizontally to obtain the center of the sheet of paper; mark it as point **A**.

2 Draw line **BC**, the middle of which is **A** .

3 Put the needle of the compass, open at the desired measurement, on point **B**; draw a semicircle to find points **a** and **b** on the vertical line.

4 With the needle still on **B**, open the compass to the font size you have chosen **[bc]** and draw another semicircle to find **d**.

5 Now move the needle to **C** and open it to the measurement **Cb**; draw another semicircle to find point **e**.

6 With the needle still on **C**, open to compass to **Cc** and draw a semicircle to find point **f**.

7 Alternate the needle between **B** and **C** to increase the circumference of your spiral.

8 Write inside the circular guidelines until you get to the center of the spiral.

YOU CAN MAKE THE SPIRAL MORE COMPLEX AND DECORATIVE BY WRITING IN THE INTERLINEAR SPACE, USING LARGER FONT AND A DIFFERENT COLOR.

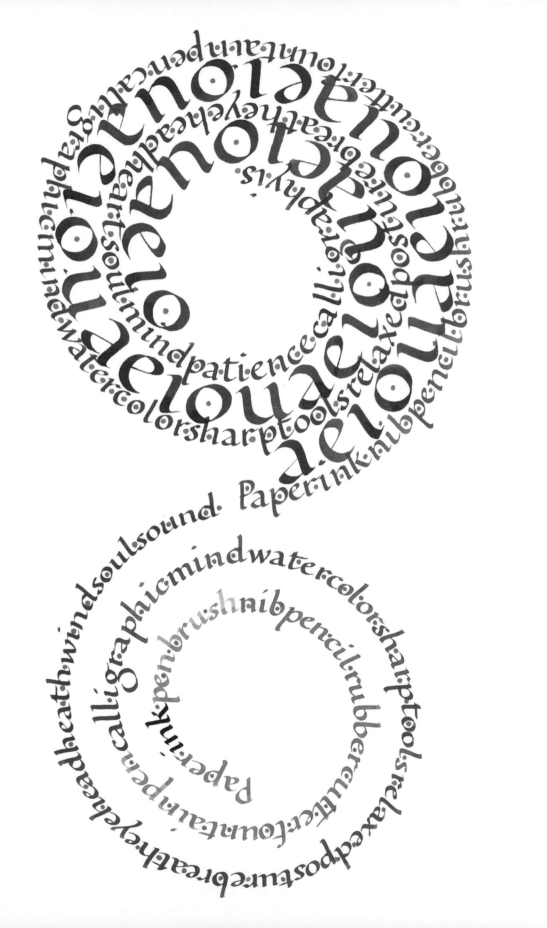

Bookmark

A beautiful idea for a small gift for a friend who is passionate about books: a bookmark specially designed for them ... or even for yourself.

1 You need a fairly thick piece of card; cut off a strip with a width of about 2 in (5 cm); the length should be about the same as that of a standard book.

2 Choose a short phrase, the font and the nib width and write a rough copy; measure the text to ensure it fits the length of the bookmark.

3 Once you've established the length of the bookmark based on the length of the phrase, draw the **A** guidelines, leaving the same sized space for the top and bottom margins **(BC)**.

4 Decide which decorative element to use for the frames in the top and bottom margins (in this case, the letter **a** of the same alphabet), and do the top margin on your rough copy with a smaller nib width than that of the central text **(D)**.

5 Now write the letters in the bottom margin so they mirror those in the top margin **(E)**.

6 Write the central phrase.

7 Check that none of the letters and words are cut off; copy them onto the card bookmark.

8 When you've finished, make hole **F** and decorate the bookmark with strips of raffia, twisted cotton yarn or thin rope, on to which you can thread small beads.

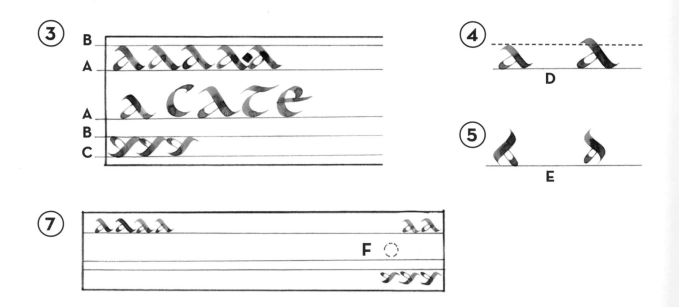

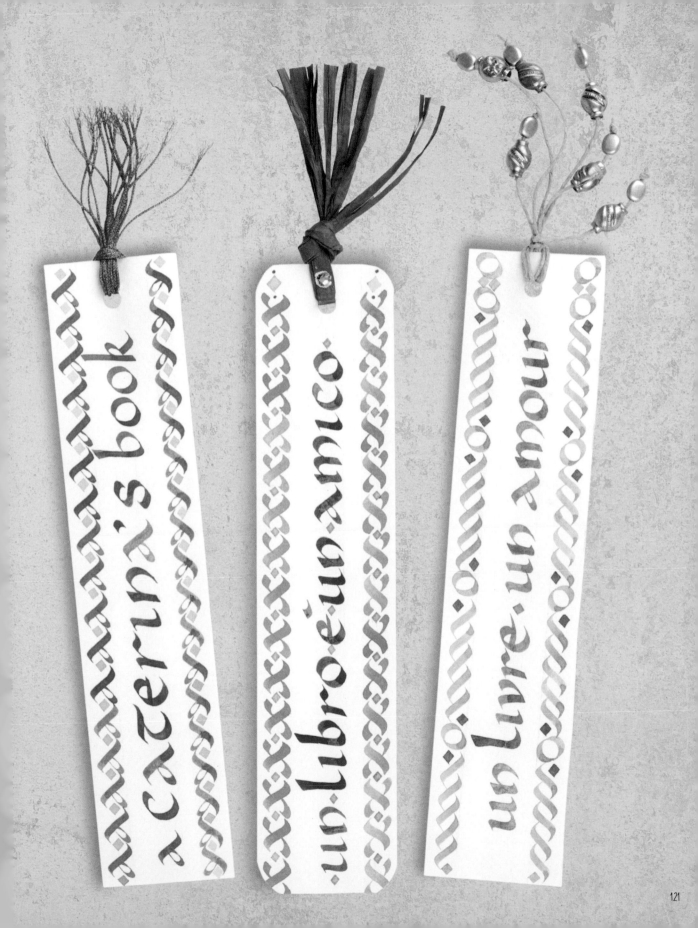

Pocket-Size Gift

If there's a phrase that moves you, or a thought that you would like to always carry with you, you can make this mini-booklet, which is also an original idea for a small gift.

1 Cut out **2** equal squares from a fairly thick piece of card.
2 Cut out **2** larger squares from a piece of decorated paper; cut off the corners.
3 Glue the card onto the paper and fold the edges of the latter inwards; glue the flaps onto the card.
4 Cut a strip of paper that is about **10** times longer than the exposed piece of card **(X 10)**.
5 Use a pencil to divide the paper into **10** sections and then draw the guidelines for the font you have chosen. Prepare a strip of lightweight paper to use for your rough copy, the same size as the first one.
6 Try a few different positions for the phrase, making sure that the letters don't touch the pencil lines of the sections, where possible.
7 Once you're happy with the text, practice folding the rough copy as shown in the figure. Remember that the two end sections will be glued onto the decorated card squares.
8 Write the final copy, fold the paper as shown in the figure and glue the end sections onto the card squares.
9 This is what the mini- booklet will look like when you've folded the paper.
10 Tie a ribbon or a strip of colored raffia around the booklet to close it.

x 10

⑦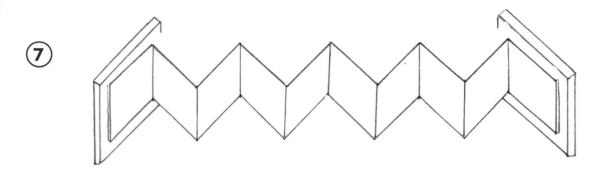

⑧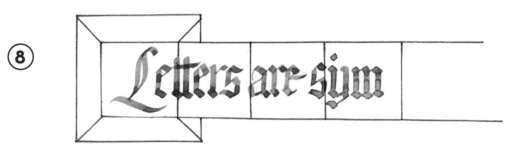

⑨ ⑩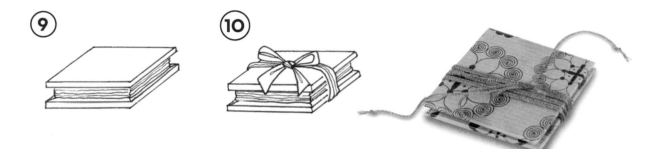

Christmas Cards

This festive card is perfect for sending heartfelt Christmas wishes.

1 You need a square envelope and a corresponding blank card.
2 Copy the measurements of the envelope onto a piece of rough paper; draw the vertical line **AB** down the middle and the horizontal line **CD**.
3 Copy the measurements of the blank card onto a piece of rough paper: draw the diagonal lines **EF** and **GH** in pencil.
4 Write the name of the person you are sending the card to, **JOYEUX NOEL** and **Merry Christmas** with different nib widths; measure the length of the text.
5 On your rough copy of the envelope, position the recipient's name below the halfway line; position the words **Merry Christmas** on the left.
6 On your rough copy of the card, position the words **JOYEUX NOEL**, in line with the diagonal lines; write **Merry Christmas** around all four edges.

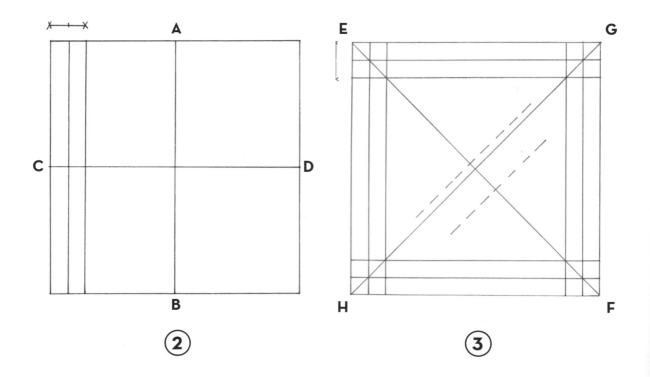

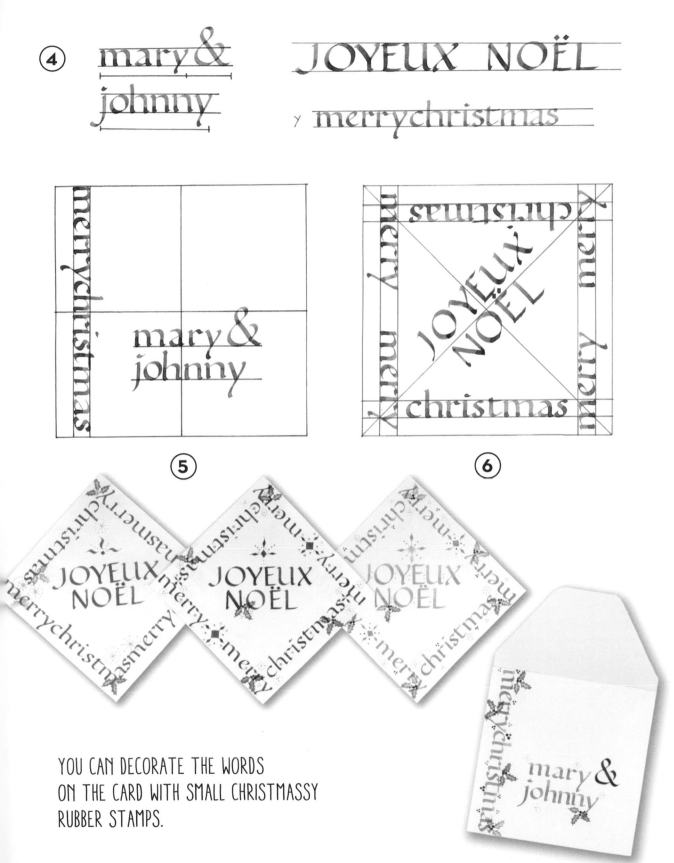

④ mary & johnny JOYEUX NOËL

y merrychristmas

⑤

⑥

YOU CAN DECORATE THE WORDS
ON THE CARD WITH SMALL CHRISTMASSY
RUBBER STAMPS.

125

Creative Envelope

If you write your envelopes in an unexpected and creative way, your friends will be even more surprised when they receive a letter from you! We have suggested a few examples here, but your imagination will no doubt come up with many more.

EXAMPLE 1

1 Draw line **AB** in pencil, dividing the envelope in half vertically.

2 Measure the space **cd** from the top edge to mark out the area in which the stamps will be affixed; then mark out the same space (**cd**) down the left side and bottom edge.

3 Halve the sections of the envelope with lines **CD** and **EF**.

4 You can continue dividing the envelope into sections, looking for balanced spaces in which to write the text. Once you've finished drawing cage-like layout, you can start to arrange the names and address of the recipient.

You can choose to evidence the initials of the names, writing them with a broader nib width than the rest of the text, and also to write on the back of the envelope. Write parts of the text in different colors. Write parts of the text with a different nib width.

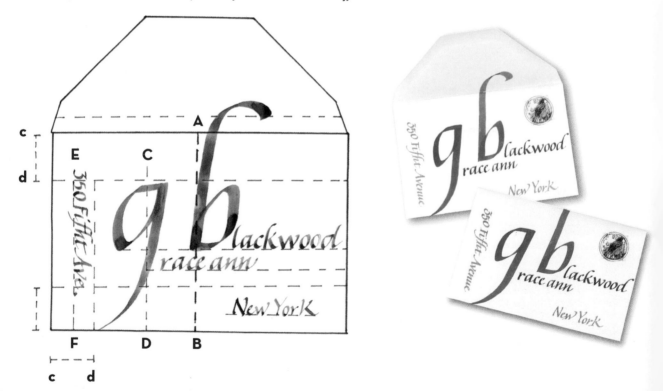

EXAMPLE 2

1 Draw line **AB** in pencil, dividing the envelope in half vertically.
2 Draw line **CD** in pencil, dividing the envelope in half horizontally.
3 Measure the space **cd** from the top edge to mark out the area in which the stamps will be affixed.
4 Write a rough copy with the name and address of the recipient and measure the length of the individual pieces of writing.
5 You can write one of the elements with a broader nib width, in this case the **&**.
6 Arrange the name and centrally on the envelope, like an epigraph.

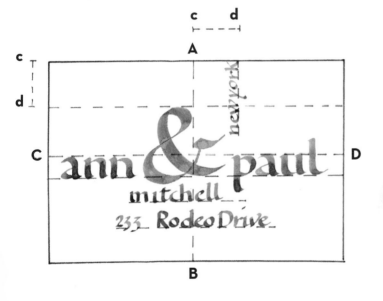

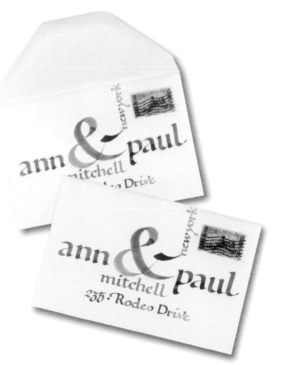

THE WORD MITCHELL IS SLIGHTLY
MORE TO THE LEFT AND IS BALANCED
BY THE DESCENDANT OF THE LETTER P.

A FEW IDEAS FOR CREATING MORE ORIGINAL ENVELOPES

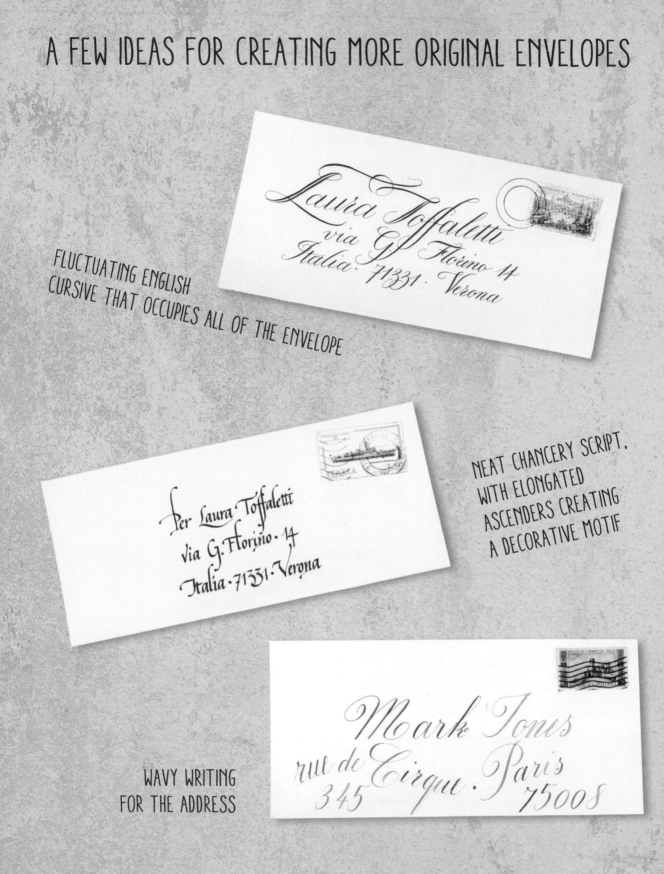

FLUCTUATING ENGLISH
CURSIVE THAT OCCUPIES ALL OF THE ENVELOPE

NEAT CHANCERY SCRIPT,
WITH ELONGATED
ASCENDERS CREATING
A DECORATIVE MOTIF

WAVY WRITING
FOR THE ADDRESS

POEMS, SHORT TEXT OR PHRASES ON THE ENVELOPES OF HAND-DELIVERED LETTERS; LET YOUR CALLIGRAPHIC CREATIVITY RUN WILD!

Christmas Box

A striking, easy-to-make box that can be used either as a place card at Christmas, or as a small gift wrapped in a calligraphy poem on a thousand other occasions!

1 Draw the pattern of the box as shown in figure **A** on a piece of rough paper: the sections are square.
2 Cut along the dotted lines.
3 Drawn figure **ABCD** in the middle, which you will only cut out when you've **finished** writing on the box.
4 Draw the guidelines as shown in figure **B**.
5 Write the text, following the direction of the arrows.
6 Cut out figure **ABCD**.
7 Fold the sections inwards and close the box.
8 Once you've checked that everything works with the rough copy, repeat on a thick piece of card.

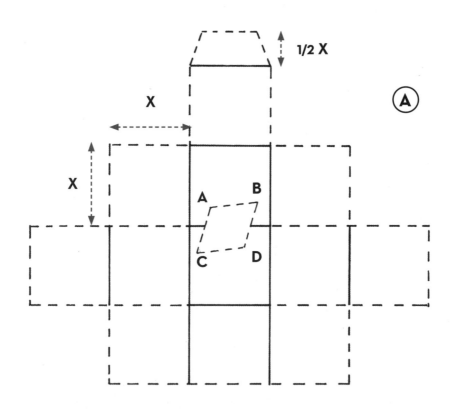

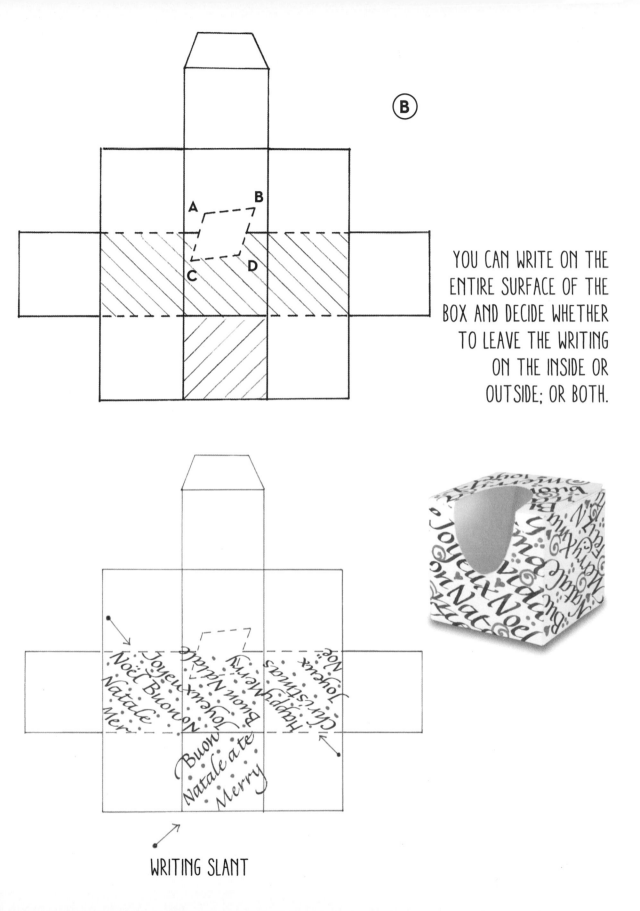

YOU CAN WRITE ON THE ENTIRE SURFACE OF THE BOX AND DECIDE WHETHER TO LEAVE THE WRITING ON THE INSIDE OR OUTSIDE; OR BOTH.

WRITING SLANT

Kids' Bedroom Family Tree

A beautiful pedigree to decorate your kids' bedroom, creating a simple illustration of family relationships. This is a project that can be added to over time with the names of new members of the family.

1 Make a list of the names of the members of your family — grandparents, their children, husband and wives, grandchildren — and draw a diagram showing their relationships.

2 Choose a font and write all the names on the list; they could have a different nib width according to the degree of kinship (*grandparents with a broader nib width than the grandchildren*).

3 Measure the length of all the names and write it next to them in pencil.

4 Prepare the rough copy: decide the size of the piece of paper and draw line **AB** in pencil to divide the page in half.

5 Starting from the bottom, write the names of the grandparents in pencil either side of line **AB**, followed by those of their children, husbands, wives and grandchildren. Try different ways of doing the foliage so that all the names are legible and none of them overlap. Leave fairly large top and bottom margins and make sure that the side margins are balanced.

6 Once you have the outline in pencil, do another rough copy to arrange the names written with a broad nib width; draw guidelines along the curved branches.

7 When the tree looks balanced on the page, you can start on your final copy; embellish it with drawings of leaves and flowers, always using a broad nib. In addition to being decorative, they help fill any gaps.

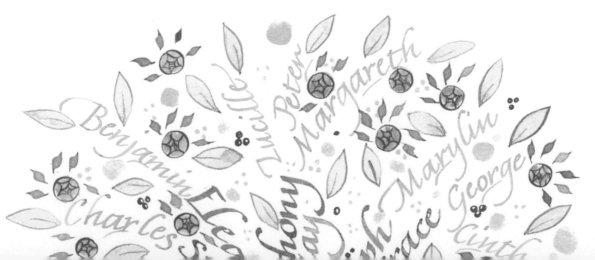

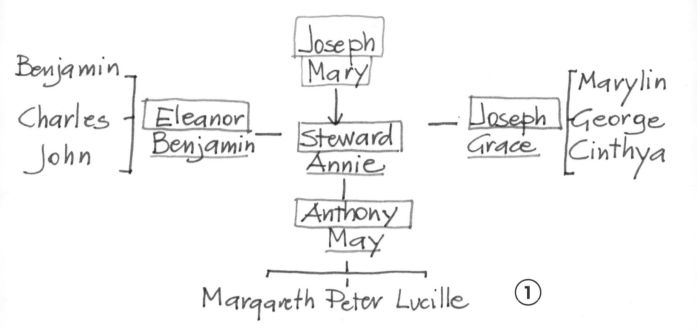

Benjamin
Charles
John
⌉
Eleanor
Benjamin
—
Joseph
Mary
Steward
Annie
—
Joseph
Grace
⌈
Marylin
George
Cinthya

Anthony
May

Margareth Peter Lucille

①

Grandpa Joseph
◄-----------------►

Grandma Mary
◄-----------------►

Steward
◄-----------------►

Our Family
◄-----------------►

Peter
◄------►

② ③

|1 2 3 4 5 6 7 8 9 10|

A

Benjamin

Charles

John

Lucille

Peter

Margareth

Marylin

Joseph Grace George

Anthya

Eleanor

Stephen

Anthony

May

Steward

Annie

Grandpa Joseph

Grandma Mary

④ ⑤

Our

Family

B

134

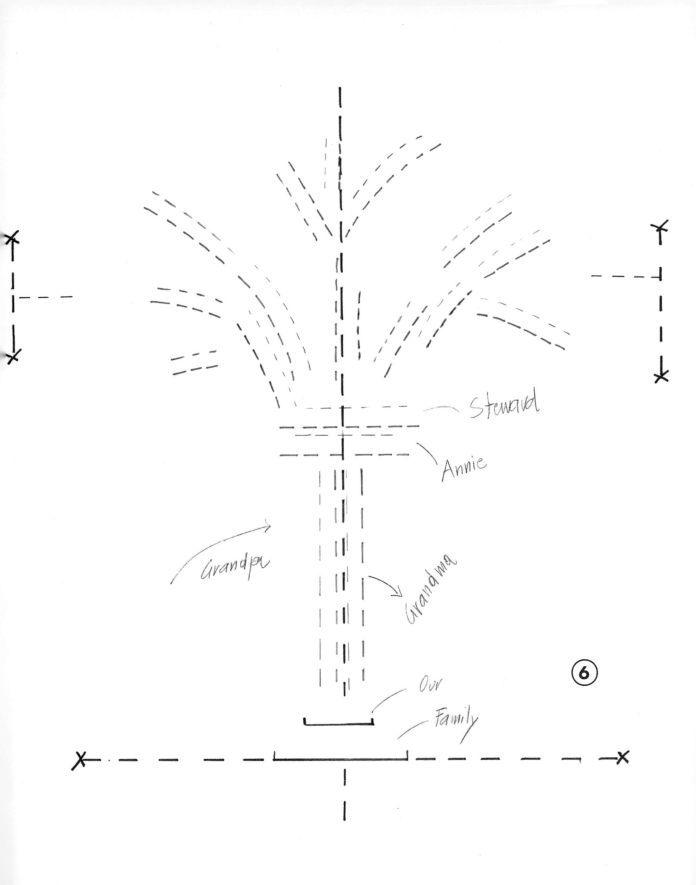

Steward

Annie

Grandpa

Grandma

Our

Family

⑥

135

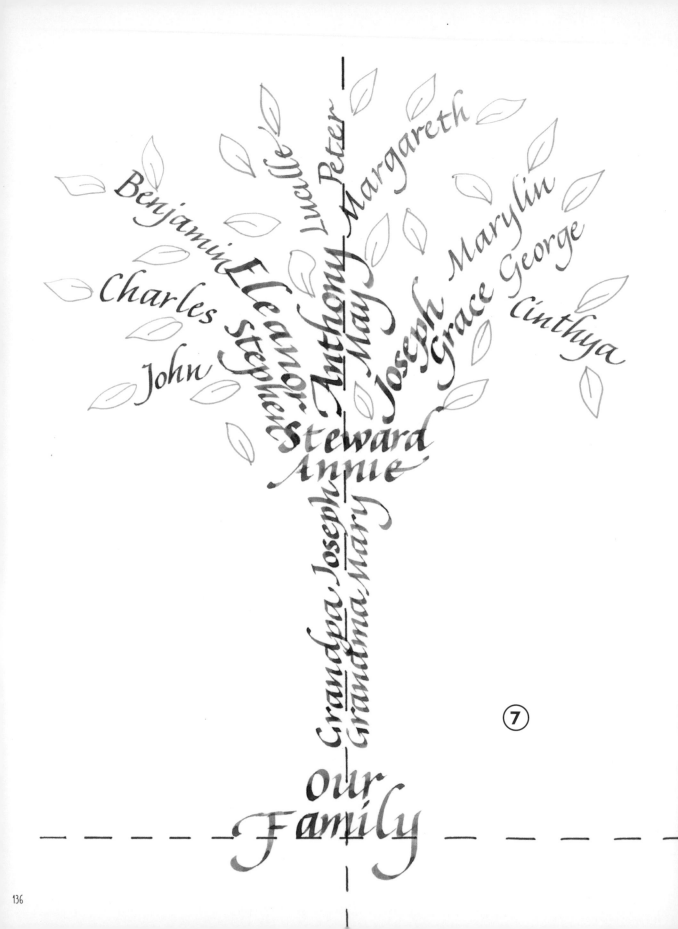

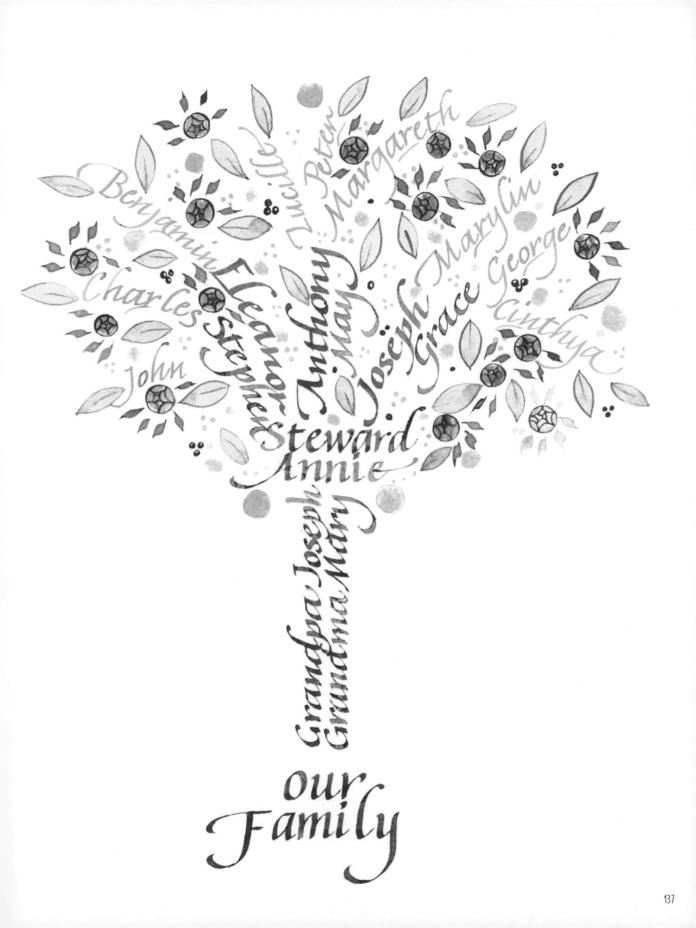

Calligraphy Poem

This Irish poem, or any other text with an average length, requires careful planning; not only for the choice of font, but also the layout of the text itself, which can be enhanced by the right balance between the format of the page and the block of text.

1 Choose the format of the page; do a rough copy, writing the entire poem left aligned. Check the critical points: the length of the rows, line spacing, no overlapping letter, the position of the title.

2 With the second draft, you can correct the parts you're not happy with: evidence the title by increasing the line spacing, make some of the lines right aligned, write some of the ascenders without the counter.

3 Try a few different layouts. To make the page more dynamic, you can choose to vary the size of the left/right and top/bottom margins, rather than using a central layout that can be a little static. Make photocopies of the second rough copy, cut out the names and arrange them on the page.

4 Now copy the guidelines onto your nice piece of paper and write your final version, consulting your preparatory drafts as you go.

An Irish Blessing ①

May the road rise up to meet you
May the wind be always
at your back. May the sunshine
warm upon your face, the rainfall
soft upon your fields, and until
meet again may God hold you
in the palm of His hand.

An Irish Blessing

(2)

*May the road rise up to meet you.
May the wind be always
at your back. May the sunshine
warm upon your face, the rainfall
soft upon your fields, and until
meet again, may God hold you
in the palm of His hand.*

An Irish Blessing

*May the road rise up to meet you.
May the wind be always
at your back. May the sunshine
warm upon your face, the rainfall
soft upon your fields, and until
meet again, may God hold you
in the palm of His hand.*

A

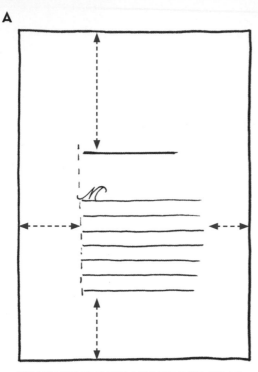

THE LEFT MARGIN IS WIDER THAN THE RIGHT, AND THE TOP MARGIN IS GREATER THAN THE BOTTOM ONE.

B

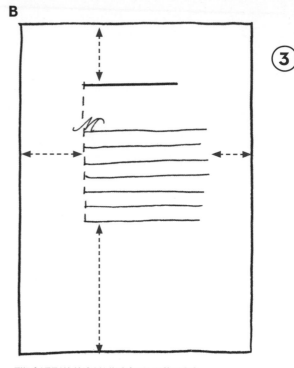

THE BOTTOM MARGIN HAS BEEN INCREASED.

C

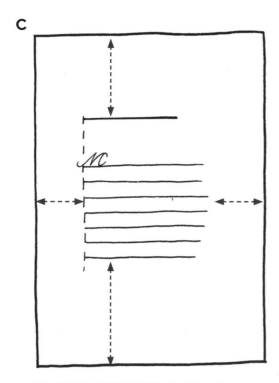

THE LEFT AND RIGHT MARGINS ARE THE SAME.

D

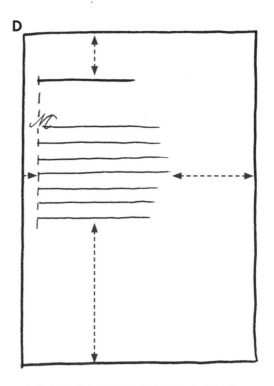

THE TEXT IS TOO CLOSE TO THE LEFT AND TOP MARGINS, MAKING THE COMPOSITION UNBALANCED.

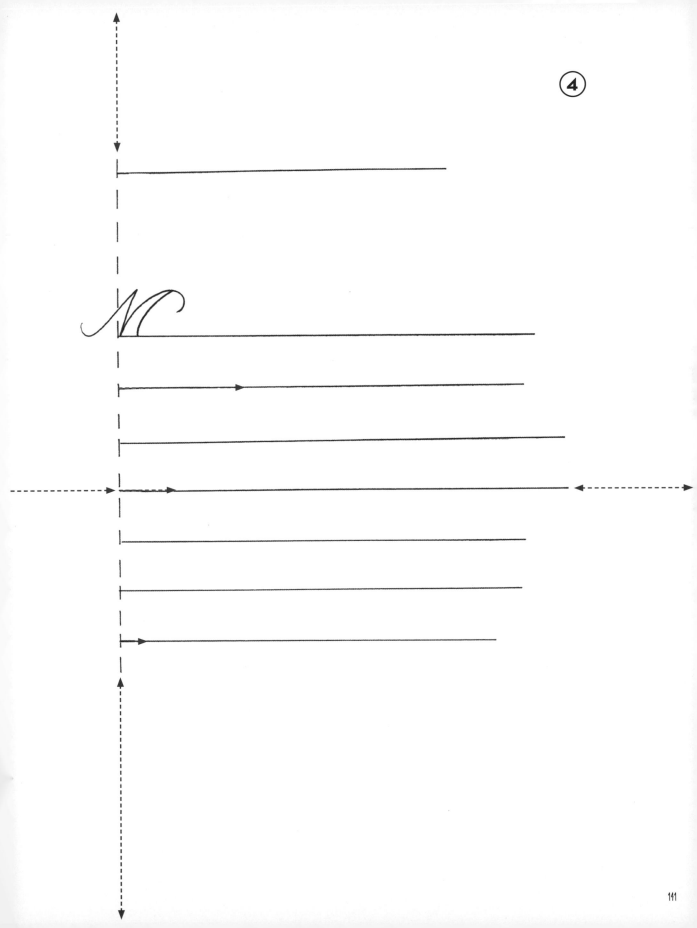

GREETING CARDS FOR EVERY OCCASION

These greeting cards don't require any special instructions; they are just more ideas for designing tasteful, creative cards especially for the people they are intended for.

PLAY AROUND WITH DIFFERENT SHADES OF RED FOR YOUR FIRST SAINT VALENTINE'S DAY CARD.

GOLD PATTERNS TO ACCOMPANY A WEDDING GIFT.

AN ELEGANT NEW YEAR CARD, WRITTEN
IN ENGLISH CURSIVE AND DECORATED
WITH RUBBER STAMPS.

Elina

Buon Anno

joyhappyness

For a New Baby

FOR THE ARRIVAL OF A NEW
BABY, APPLY TINY FABRIC
FLOWERS WRAPPED IN
WRAPPING PAPER.

Calligraphy Exercises

There are not many rules in calligraphy, but those which exist are very clear: nib width, angle and guidelines are terms that whoever starts learning this discipline will frequently encounter. These rules have become established over time, although they do not differ much from those followed by scribes to transcribe illuminated manuscripts many centuries ago: this is because they work.

In fact, if the pen angle changes continuously it is impossible to write a letter correctly, just as it is important to respect the guidelines in order to achieve a satisfactory result. With practice you'll learn that certain things that seem small or insignificant are actually extremely important: respecting the shape; the ability to consider the strokes both individually and as a whole; the importance not only of the strokes, but also of the white spaces inside the letters; the weight of the letter.

You will learn how to use new tools for writing, which are totally different from those you have been accustomed to since you wrote your first words; this will initially make you doubt your ability to write, but with constant and careful practice the results will come.

The art of calligraphy is a slow process; one that requires time, space and patience; this is why many people associate it with a particular moment in a time that seems to have forgotten these things, through which you will discover the great potential and satisfaction of a well-written letter or a well-composed sentence.

RUSTIC CAPITALS

A

B

C

D

E

F

G

H

I

J

K

L

M

N

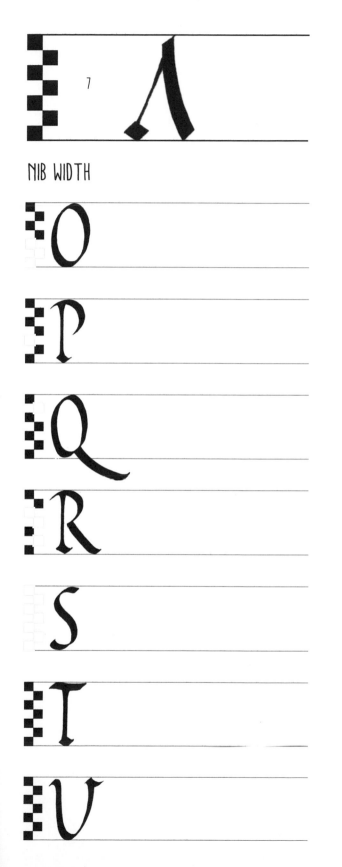

NIB WIDTH

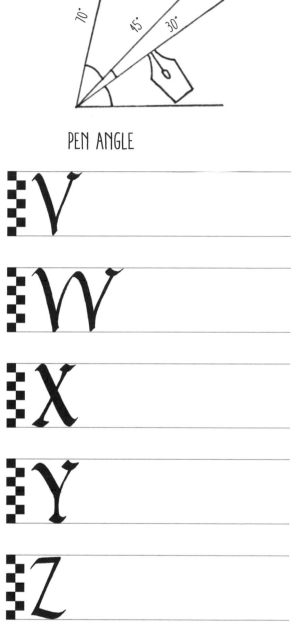

PEN ANGLE

A B C D E
F G H I J K L M
N O P Q R S T U
V W X Y Z

ROMAN CAPITALS

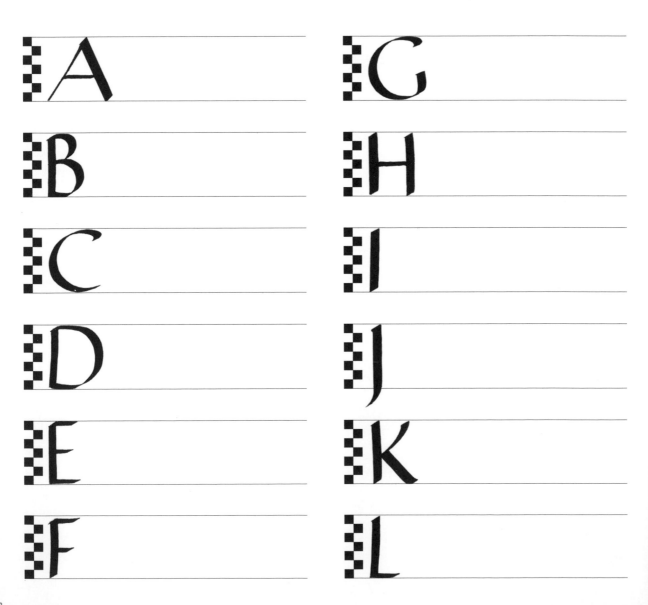

A

G

B

H

C

I

D

J

E

K

F

L

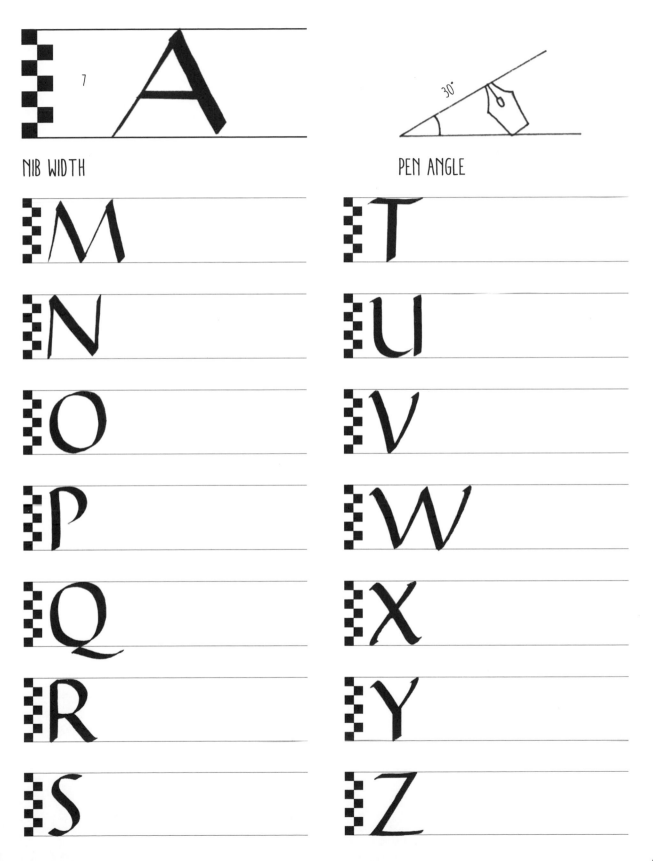

A

7

NIB WIDTH

30°

PEN ANGLE

M

N

O

P

Q

R

S

T

U

V

W

X

Y

Z

UNCIAL

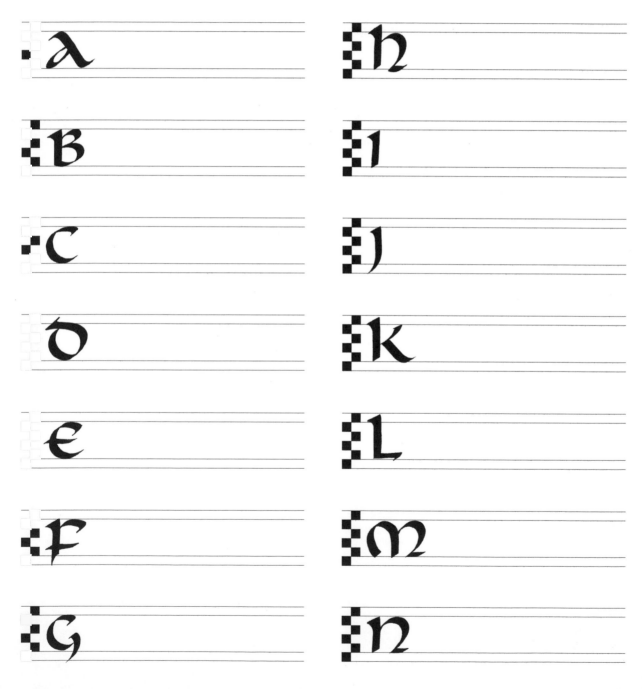

NIB WIDTH

PEN ANGLE

30°

a

c

p

q

r

s

t

u

v

w

x

y

z

A B C D E F
G H I J K L M
N O P Q R S T
U V W X Y Z

carolingian

a h

b i

c j

d k

e l

f m

g n

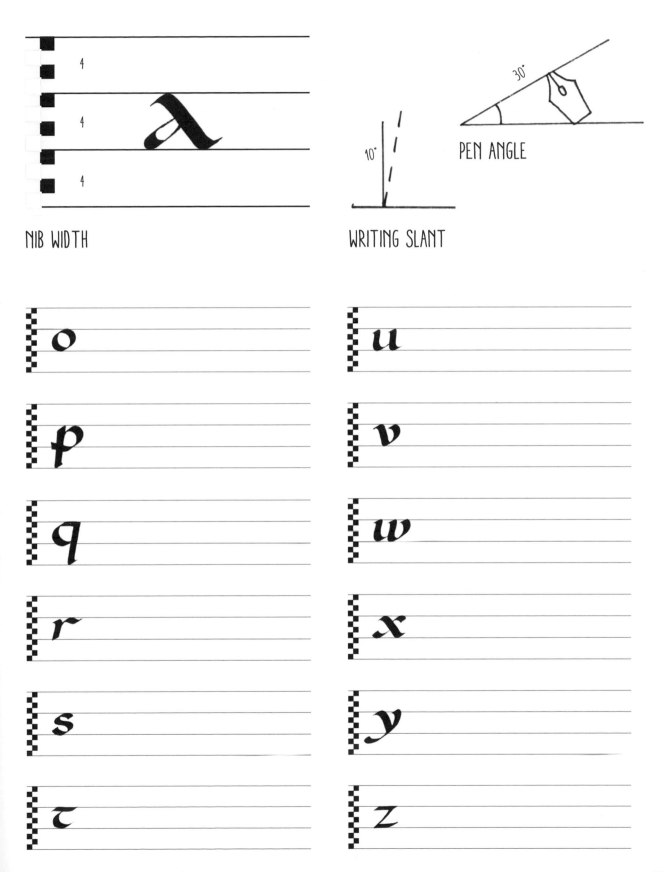

NIB WIDTH

WRITING SLANT

PEN ANGLE

o

p

q

r

s

τ

u

v

w

x

y

z

Textura

a

b

c

d

e

e

f

g

h

h

i

j

k

l

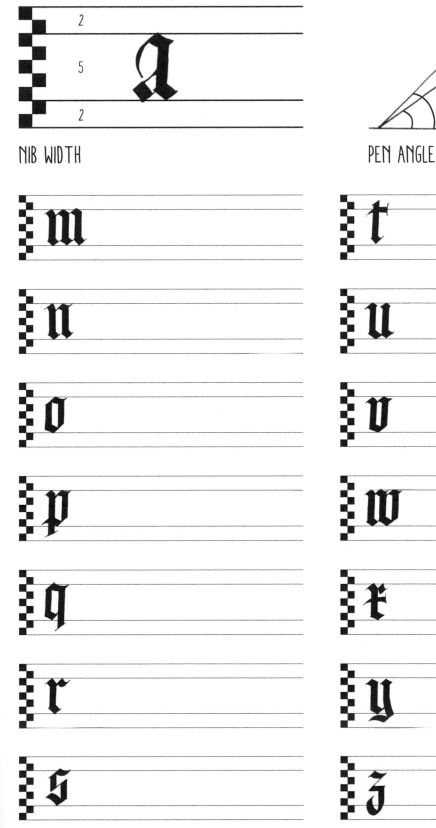

NIB WIDTH

VERTICAL STROKES 35°;
SLANTING STROKES 45°

PEN ANGLE

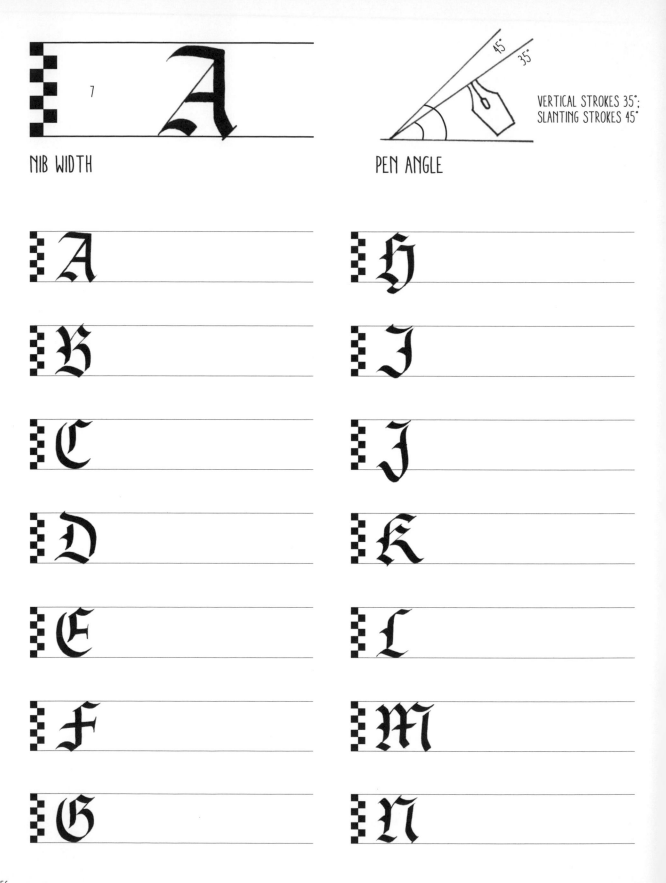

NIB WIDTH

7

PEN ANGLE

VERTICAL STROKES 35°;
SLANTING STROKES 45°

O

P

Q

R

S

T

U

V

W

X

Y

Z

ABCDE
FGHIJKLM
NOPQRSTU
VWXYZ

Fraktur

a

b

c

d

e

f

g

h

i

j

k

l

m

n

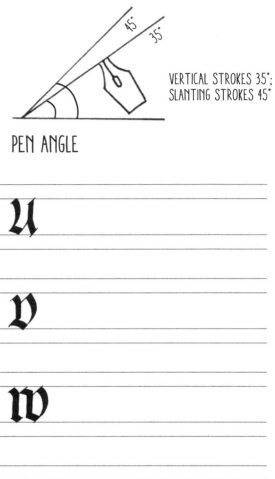

NIB WIDTH

PEN ANGLE

VERTICAL STROKES 35°;
SLANTING STROKES 45°

o

u

p

v

q

w

r

x

s

y

f

z

t

z

NIB WIDTH

7

PEN ANGLE

VERTICAL STROKES 35°;
SLANTING STROKES 45°

𝔘

𝔅

ℭ

𝔇

𝔈

𝔉

𝔊

ℌ

ℑ

𝔍

𝔎

𝔏

𝔐

𝔑

O

P

Q

R

S

T

U

V

W

X

Y

Z

ABCDE
FGHIJKLM
NOPQRSTU
VWXYZ

Foundational

a h

b i

c j

d k

e l

f m

g n

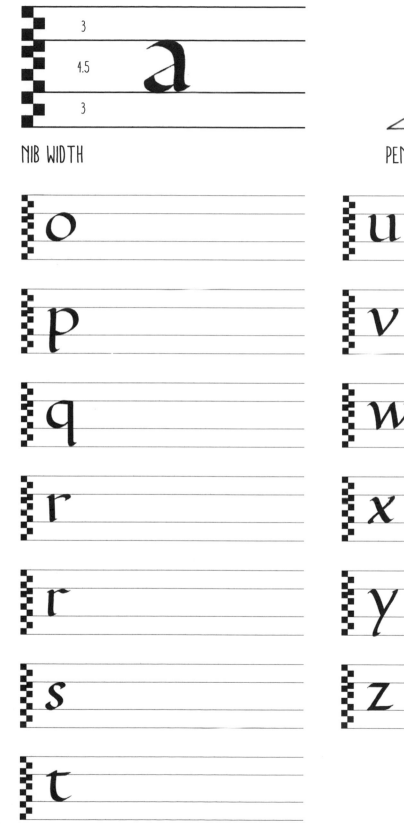

3

4.5

a

3

NIB WIDTH

30°

PEN ANGLE

o

p

q

r

r

s

τ

u

v

w

x

y

z

A 7

NIB WIDTH

30°

PEN ANGLE

A

B

C

D

E

F

G

H

I

J

J

K

L

M

N

O

P

Q

R

S

T

U

V

W

X

Y

Z

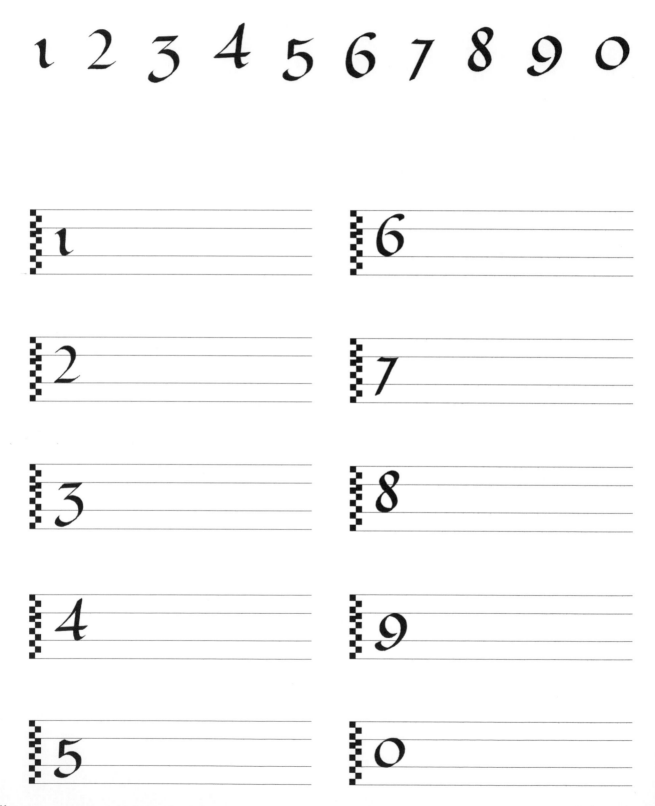

Roundhand

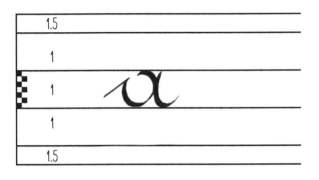

| 1.5 |
| 1 |
| 1 |
| 1 |
| 1.5 |

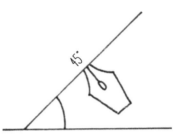
45°

HEIGHT BETWEEN THE ASCENDERS AND DESCENDERS

PEN ANGLE

a

f

b

g

c

h

d

i

e

j

k

t

l

u

m

v

u

w

o

x

p

y

q

z

r

s

a b c d e f
g h i j k l m
n o p q r s t u
v w x y z

168

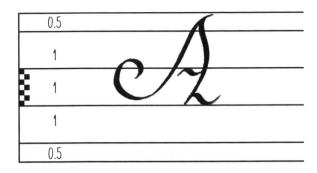

HEIGHT OF THE CHARACTER

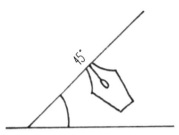

PEN ANGLE

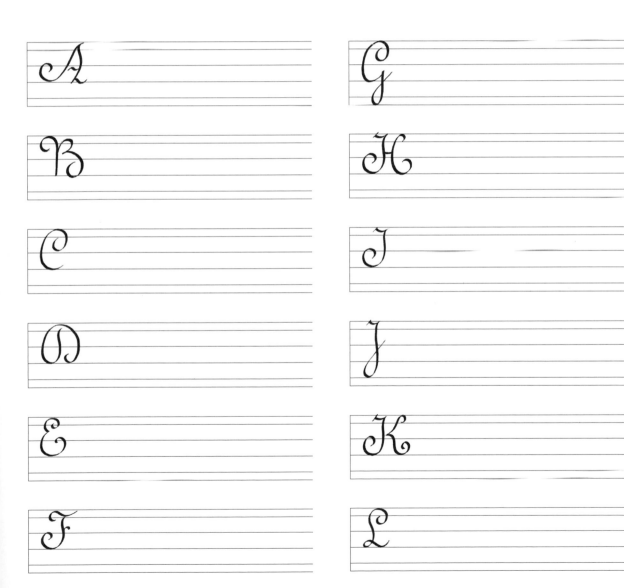

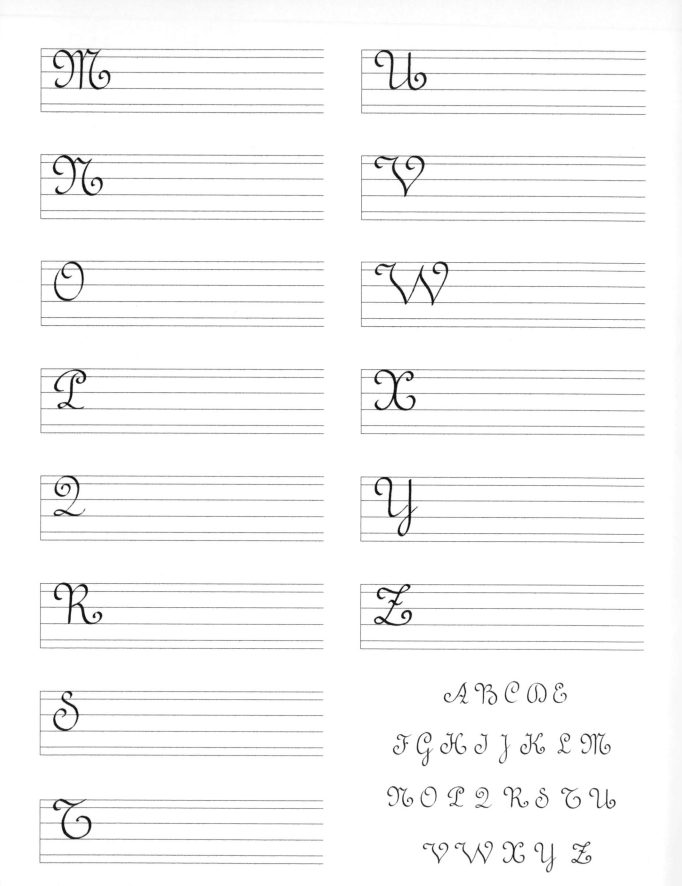

1 2 3 4 5 6 7 8 9 0

1

2

3

4

5

6

7

8

9

0

Chancery

a

b

c

d

e

f

f

g

g

h

ij

k

l

m

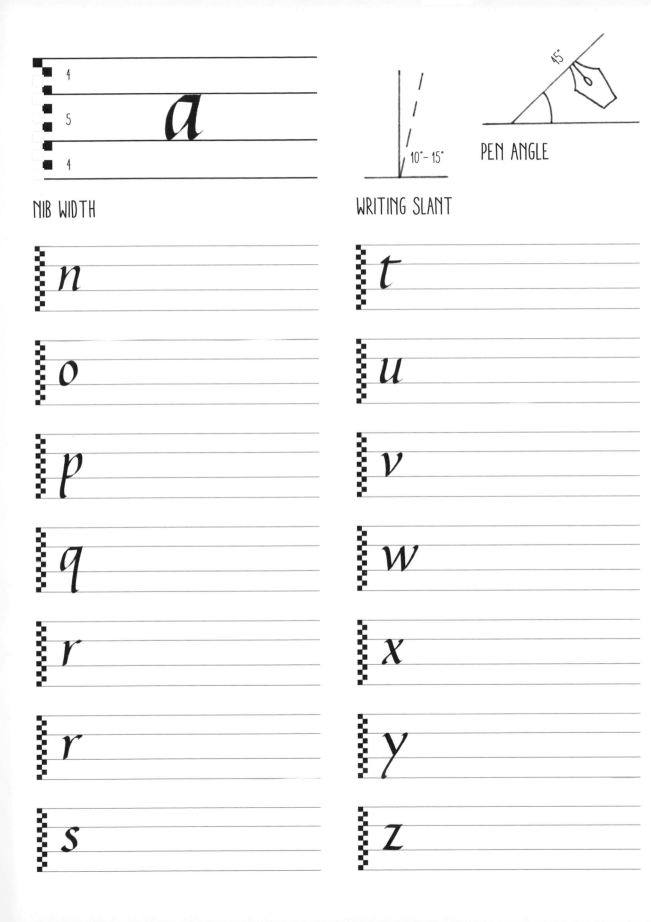

NIB WIDTH

WRITING SLANT

10° – 15°

PEN ANGLE

45°

a

4
5
4

n

o

p

q

r

r

s

t

u

v

w

x

y

z

7.5

NIB WIDTH

10°–15°

PEN ANGLE

45°

A

B

C

D

E

F

G

H

I

J

K

L

M

N

O

P

Q

R

S

T

U

V

W

X

Y

Z

A B C D E
F G H I J K L M
N O P Q R S T U
V W X Y Z

175

1 2 3 4 5 6 7 8 9 0

1

6

2

7

3

8

4

9

5

0

English cursive

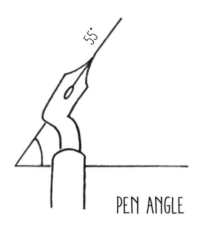

HEIGHT OF THE CHARACTER

PEN ANGLE

k

t

l

u

m

v

n

w

o

x

p

y

q

z

r

a b c d e f
g h i j k l m
n o p q r s t u
v w x y z

s

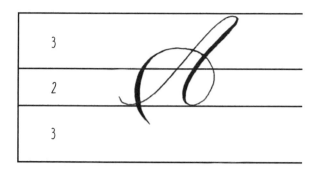

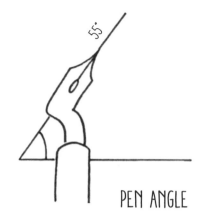

HEIGHT OF THE CHARACTER

PEN ANGLE

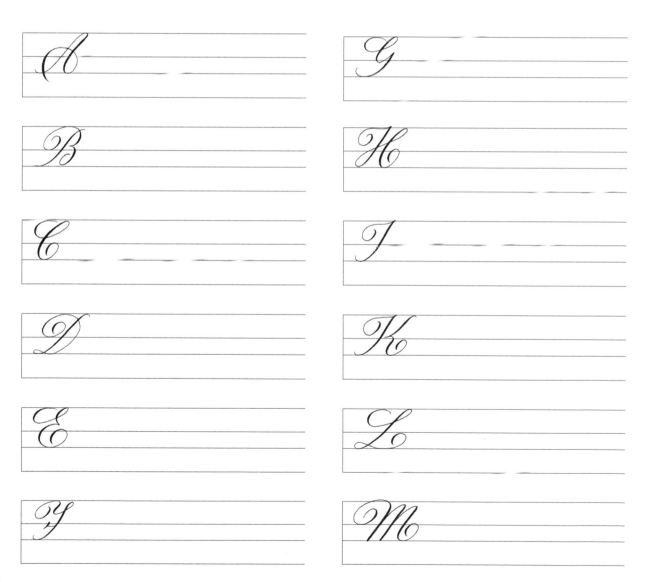

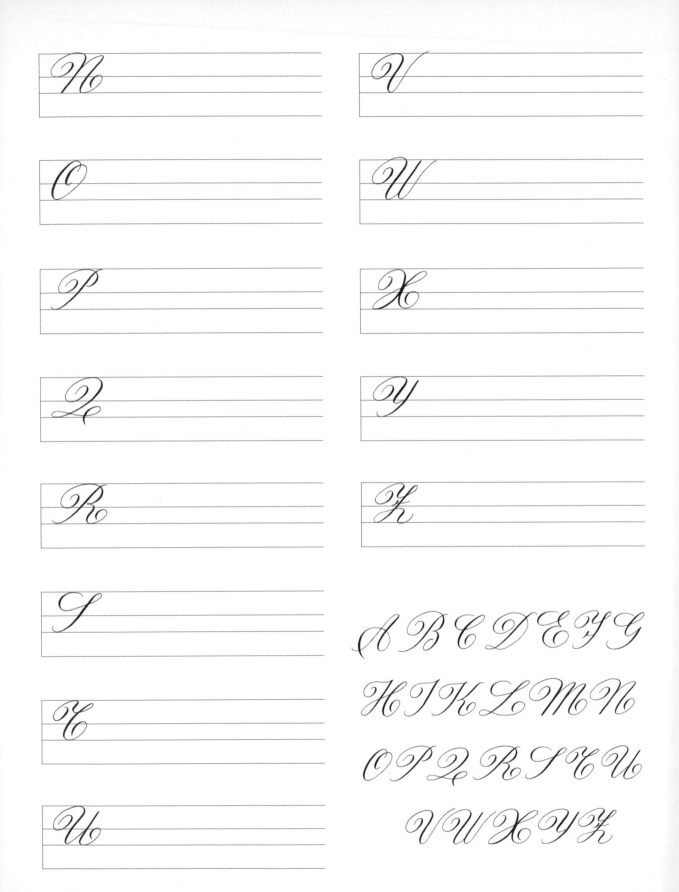

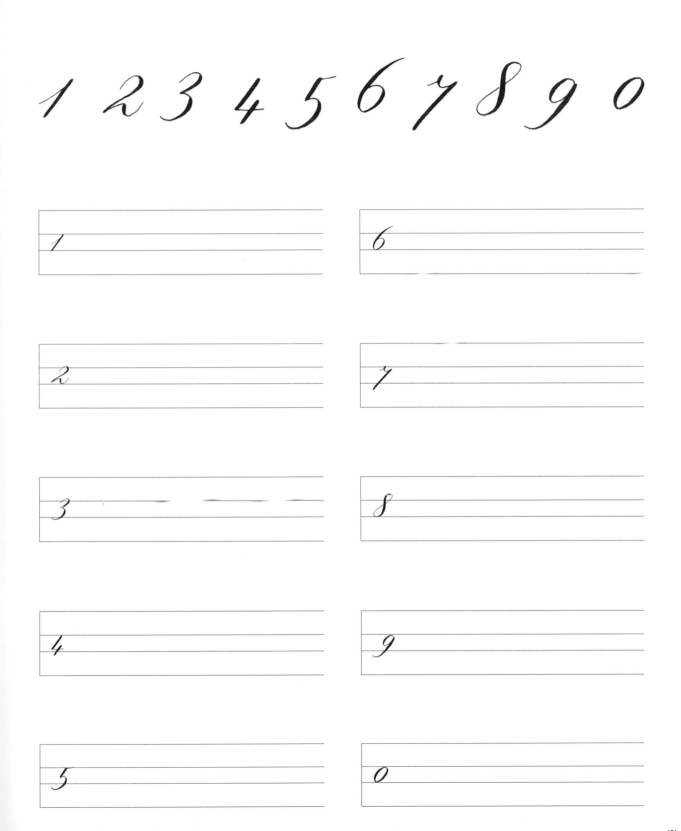

EXERCISES TO DO ON YOUR OWN

Now that you have practiced the exercises on the previous pages, try to compose some sentences on the following blank pages. Don't forget to always draw the guidelines, marking the height of the font that you have chosen and the height of the interlinear space.

HAVE FUN!

Laura Toffaletti has a Diploma in Scenography and Sculpture from the Cignaroli Academy of Fine Arts in Verona. She has worked as an illustrator for many publishers, producing children's books, hand-written and hand-illustrated cookbooks and calendars, to mention but a few. Having always been passionate about strokes, signs and characters, in 1994 she came across the Italian Calligraphy Association and she has been studying this art since then, thanks to the teachings of both Italian and foreign master penmen. She prefers the expressive and informal forms of characters, which she uses in her work by superimposing and layering texts and images, in the conviction that the more the words are hidden, the more desire there is to read them. She also uses calligraphy and illustrations together to create works on paper and canvas, blending inks and watercolor, illuminated with delicate touches of gold leaf, which she presents at personal and collective exhibitions. She holds Calligraphy courses in Verona, but that's not all; for those who have never lost their passion for letters or those who are curious to learn about this ancient discipline for the first time, she has also published the following calligraphy manuals: "L'arte di scrivere bello", "Calligrafia", and "Esercizi di Calligrafia."

PHOTO CREDITS

All photographs are by Laura Toffaletti except the following:
Art Collection 2 / Alamy Stock Photo/IPA, page 7
melnikof/Shutterstock, pages 10-11, 12-13
Daria Minaeva/123RF, pages 14-15
Valentina Giammarinaro/Archivio White Star, pages 16-17, 18, 19, 20, 21, 116, 117, 121, 123, 125, 126, 127, 128, 129, 131, 142, 143
Lost Mountain StudioShutterstock, pages 22-23
Eivaisla/iStockphoto, pages 40-41

The Publisher wishes to thank Gloria Gallarati at "Rosso Smeraldo" (Vercelli, Italy) for her precious collaboration and for having provided the calligraphy material for the photographs.

BIBLIOGRAPHY

Hermann Zapf "Classical Typography in the Computer Age" Oak Knoll Press, 1991 • Martin Andersch "Symbols, Signs and Letters" Design Pr, 1989 • Giulia Bologna "Illuminated Manuscripts: The Book Before Gutenberg" Weidenfeld & Nicolson, 1988 • Salvatore Gregorietti - Emilia Vassalli "La forma della scrittura" Feltrinelli, Milan, 1988 • Giovanni De Faccio - Anna Ronchi - James Clough " La calligrafia" Vinciana Editrice, Milan, 1997 • Donald Jackson "The Story of Writing" Littlehampton Book, 1981 • Judy Martin "The Complete Guide to Calligraphy" Phaidon Press 1992 • Eric Hebborn "Italico per italiani" Angelo Colla Editore, Vicenza 2004 • David Harris "The Calligrapher's Bible" Barrons Educational, 2003 • Mary Noble - Janet Mehigan "The Calligrapher's Companion" Thunder Bay Pr, 1997 • Vivien Lunniss "Complete Guide to Calligraphy" Search Press Ltd, 2015 • Luca Barcellona "Take Your Pleasure Seriously" Lazy Dog Press, Milan, 2012 • Edward Johnston "Writing & Illuminating & Lettering" D&B Books, 2016 • Steven Heller - Lita Talarico "Free Hand: New Typography Sketchbooks" Harry N. Abrams, 2018 • Gaye Godfrey-Nicholls "Mastering Calligraphy" Chronicle Books, 2013 • Andrew Robinson "Writing and Script: A Very Short Introduction" OUP Oxford, Kindle Edition, 2017.